ANSEL ADAMS

An American Place, 1936

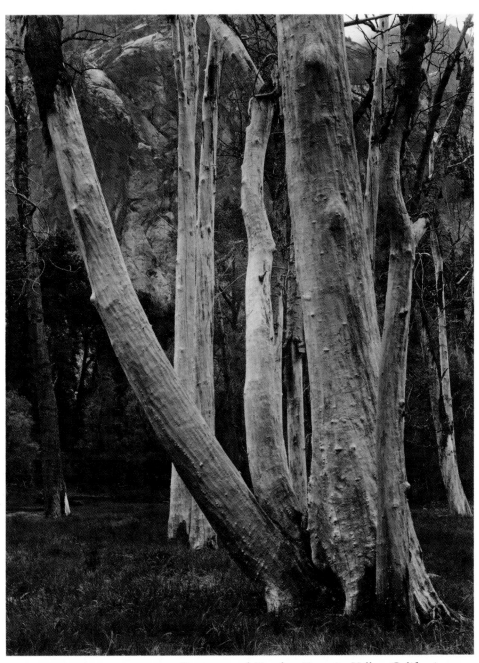

Cottonwood Trunks, *Yosemite Valley, California, 1932*

ANSEL ADAMS
An American Place, 1936

by Andrea Gray

Funded by BankAmerica Foundation

Center for Creative Photography · University of Arizona

EXHIBITION SCHEDULE

May 7–July 4, 1982
San Francisco Museum of Modern Art
San Francisco, California

October 17–November 24, 1982
Center for Creative Photography
University of Arizona
Tucson, Arizona

December 14, 1982–January 30, 1983
Seattle Art Museum
Seattle, Washington

February 18–April 3, 1983
Museum of Fine Arts, Houston
Houston, Texas

April 13–May 30, 1983
The Art Institute of Chicago
Chicago, Illinois

June 11–July 31, 1983
Corcoran Gallery of Art
Washington, D.C.

Composed and Printed in the United States
Library of Congress Catalog Card Number 82-70334

V. S. W.
Review copy
21 February 1983

CONTENTS

ACKNOWLEDGMENTS

THIS RE-CREATION OF ANSEL ADAMS'S SEMINAL EXHIBITION in 1936 at Alfred Stieglitz's An American Place gallery is made possible by a generous grant from the BankAmerica Foundation. The national tour of the exhibition reflects a common desire by the Foundation and the Center for Creative Photography to honor Adams for his half-century of contributions to American art.

Andrea Gray, former assistant to Adams, curated the exhibition and wrote the text for the accompanying catalog. We are deeply grateful to her for the new insights and information that her essay provides for scholars and admirers of Adams's photography.

We are especially indebted to the following lenders to the exhibition: the Art Museum, Princeton University; Mr. and Mrs. Wilhelmus B. Bryan III; the Art Institute of Chicago; Mariana Cook; Patricia English Farbman; the Lunn Gallery; the Museum of Modern Art; and the Philadelphia Museum of Art.

We also wish to acknowledge and thank the institutions participating in the exhibition tour: the Art Institute of Chicago; Corcoran Gallery of Art; the Museum of Fine Arts, Houston; San Francisco Museum of Modern Art; and the Seattle Art Museum.

Finally, we wish to express our gratitude to Ansel Adams whose cooperation made the project a pleasure. Through his inimitable vision and commitment to excellence, he has preserved for future generations the spirit of "the Place."

JAMES L. ENYEART

PREFACE

IN THE FALL OF 1936, ALFRED STIEGLITZ PRESENTED an exhibition of Ansel Adams's photographs at An American Place in New York City. The exhibit of forty-five photographs met with critical success. As Adams's assistant from 1974 to 1980, I often heard him refer to the exhibit as the finest he had ever had. In organizing the correspondence in his archive, I was struck by the frequent superlative references to the show. David McAlpin, for instance, recounted a conversation with Stieglitz in 1941 in which Stieglitz wondered if Adams could ever produce as fine a show. Considering that Adams had had hundreds of one-man shows at the best museums and galleries in the world, I was puzzled by such references and wondered what had made the exhibition at An American Place so special.

I found a copy of the checklist for the show and was surprised to recognize very few of the titles. When asked about the images, Adams said he had not printed most of them for years. I began to hunt through boxes of his early work, books, and periodicals. In some cases, a print would frustratingly be titled simply *Snow* or *Fence.*

Gradually I learned which images had been included in the show and began researching the location of the actual photographs. From correspondence between Stieglitz and Adams, I discovered that the most prominent buyer at the show had been David McAlpin. He had divided his photographic collection among three institutions: the Museum of Modern Art, the Metropolitan Museum of Art, and the Princeton University Art Museum. Studying the photographs in their collections, I was able to determine which were from the 1936 show. The characteristics of these prints gave me clues to help identify the others: a powerful sense of light, a broad range of tones, a subtle but brilliant print quality, and physical details, such as, the type of mat board and label. I was able to locate thirty-five of the original forty-five photographs in the exhibition.

I could see why Stieglitz and McAlpin had always referred to the photographs in the show in such superlatives: they were quite simply among the most beautiful photographs I had ever seen. Their small size and subject matter were unusual compared to recent work by Adams. They were contact prints or very slight enlargements, and the subjects were often common objects like scissors and thread, fences, gravestones, or a windmill: a textbook sampling of the work of Group $f/64$, characterized by Adams's exceptional print quality. Only three of the images could be called landscapes, and these barely hinted at the sense of vast space that characterizes Adams's heroic images of the 1940s.

Inspired by this extraordinary body of work, I decided to re-create the exhibition using the original prints. Of the thirty-five that I had located, twenty-nine were available for loan. The remaining sixteen images are represented by substitute prints which, whenever possible, were made in or close to the fall of 1936. Adams made six substitute prints in the fall of 1981 for those images not available as vintage prints from the 1930s.

The re-creation of the exhibition is the result of four years of research. Adams has been most generous with his time answering my questions and making substitute prints as needed. Many of his friends shared their experiences: Doris Bry, Jules Eichorn, Patricia English Farbman, Katharine Kuh, Helen LeConte, David McAlpin, Oliene Mintzer, Beaumont Newhall, Dorothy Norman, and Elizabeth Raymond Thomas. Others have helped in a variety of ways: Virginia Adams, Mary Alinder, Robert Baker, John Sexton, Chris Rainier, James Barclay, Bill Turnage, Anne Horton, Stanley Stillman, and Christopher Gray. Georgia O'Keeffe and Juan Hamilton were especially helpful. I wish to thank the Collection of American Literature, Beinecke Rare Book and Manuscript Library at Yale University for permission to quote from letters to Stieglitz. Jim Enyeart and the staff of the Center for Creative Photography were indispensable and made material from the Ansel Adams Archive available. I am grateful to the collectors and museums that loaned prints for the exhibit.

ANSEL ADAMS

An American Place, 1936

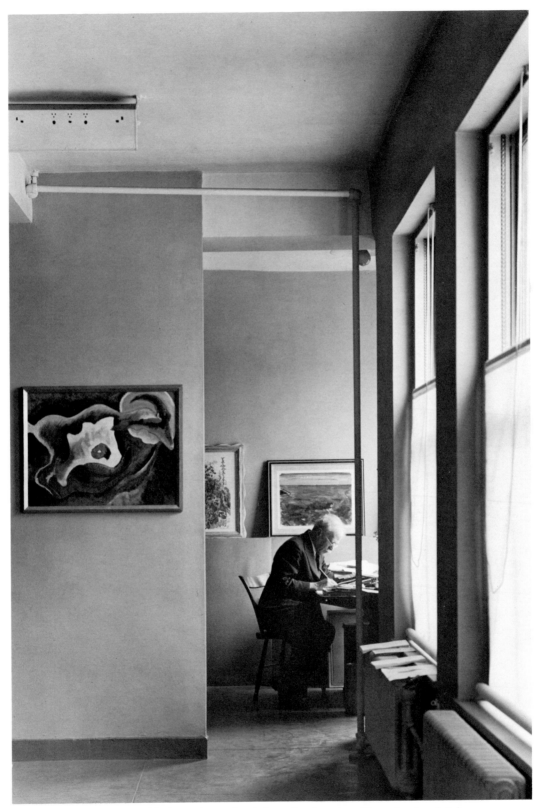

Alfred Stieglitz at his desk at An American Place, by Ansel Adams, ca. 1939

ANSEL AND VIRGINIA ADAMS ARRIVED IN NEW YORK in the early hours of a cold March morning in 1933 after a grueling five-day train trip across the country from San Francisco. They checked into a modest hotel, the Pickwick Arms, at 51st Street and Lexington Avenue, and after a shower and breakfast, Adams set off with a portfolio of his photographs. Past garbage cans in a drizzling rain, he walked the few blocks to 53rd Street and Madison Avenue. There at 509 Madison on the seventeenth floor (Room 1710) he met Alfred Stieglitz at his gallery, An American Place. The meeting changed Adams's life.

It was the height of the depression, and Adams had come to New York, in his words, "to make my fortune."[1] One of his goals was to meet Stieglitz, whose reputation as a photographer he knew, and to visit the Place. He had never seen a photograph by Stieglitz nor a copy of *Camera Work,* but he "set a priority to meet Stieglitz and get it over with as I had heard he was a tough customer."[2]

Stieglitz received Adams in a manner that would have deterred any young artist. He dismissed Adams's letter of introduction from Mrs. Sigmund Stern (one of Adams's patrons in San Francisco) with words to the effect that she had money but that was all. He then ordered Adams to return that afternoon if he wanted to show his work.

Adams was insulted by Stieglitz's arrogance, which contrasted so sharply with the warm hospitable atmosphere of San Francisco, and he considered skipping the afternoon meeting altogether. But Virginia Adams urged him to return, reminding him that they had come a long way with a chief purpose being to meet Stieglitz. More gracious that afternoon, Stieglitz looked through Adams's photographs twice without uttering a word. Finally, Stieglitz closed the portfolio, saying that the photographs were among "the finest prints I have ever seen."[3]

There is no record of the photographs that Adams showed Stieglitz on that first visit. He remembers taking to New York "the best"[4] of

his work at the time: a copy of *Taos Pueblo* (his first book, which included original photographs), photographs of the landscape in the High Sierra and subjects like anchors (Plate 32) and gravestones (Plate 29). He recalls that Stieglitz responded to the direct, simple quality of the photographs, and that he was particularly excited by *Taos Pueblo* because of the expressive quality of the photographs and the book's elegant design.

Adams visited Stieglitz several more times during his stay in New York. He also visited the Julien Levy Gallery and the Metropolitan Museum of Art. He and his wife toured the city, including the standard tourist trip to the top of the Empire State Building. They even spent an evening at "21," which Virginia Adams described to the family as "the most famous speakeasy in town."[5]

Professionally, Adams's visit to New York was a success. His photographs were "more than favorably received,"[6] and the Delphic Studio agreed to present his first New York show the following November. The highlight of the trip, however, was clearly the meeting with Stieglitz, to whom he wrote on his return to San Francisco: "I trust you will believe me when I say that my meetings with you touched and clarified many deep elements within me. It has been a great experience to know you."[7]

Adams's friends recalled that he was "thrilled"[8] with Stieglitz and talked of him constantly: "It was Stieglitz this and Stieglitz that."[9] Six months after their meeting, he wrote to Paul Strand: "I am perplexed, amazed, and touched at the impact of his [Stieglitz's] force on my own spirit. I would not believe before I met him that a man could be so psychically and emotionally powerful."[10]

He had also fallen under the spell of the Place. Forty-eight years later he vividly recalled the first show he had seen there, an exhibition of paintings by Arthur Dove, as "a whole series of sapphires."[11]

Due in part to his trip to New York, Adams decided to open a gallery in San Francisco. He wrote to Stieglitz in June 1933:

> *I am writing to tell you of an experiment I am undertaking. I have secured an admirable location downtown in San Francisco as a studio for my work. In conjunction with the studio is a gallery—very simple, fairly spacious, and well lighted. I am planning to operate this gallery as a center for photography. There is nothing of its kind out here. . . . My venture is not an attempt to imitate what you have done at An American Place—that would be more than ridiculous to try. . . . It is an attempt to experiment with public response to fine photography.*[12]

The Ansel Adams Gallery opened in September 1933 with a show of photographs by Group *f*/64. Adams intended to show the work of only the finest photographers, but artists like Stieglitz, Sheeler, and Strand could not provide shows. He found it impossible to secure enough first-rate photographs to exhibit, and he was forced to broaden the focus of the gallery to include other media: paintings, drawings, and sculpture by artists like Jean Charlot, John Marin, William Zorach, and Benny Bufano.

Invitation to opening of the Ansel Adams Gallery.

Adams had hoped to promote his name through the gallery in order to secure professional work such as portraits or advertising commissions, but very little work was forthcoming. Sales from the exhibits were scarce at best, and it is difficult to imagine the energetic Adams sitting in a room full of pictures for sale. After several months he wrote Stieglitz that he was severing his connection with the gallery:

Here I am installed once again in a simpler environment and quite contented and busy. I could not operate both my photography and an art gallery and do them both well. I was losing out painfully in the photography and wearing myself out in the bargain.[13]

And Stieglitz replied:

Of course I frequently wondered how long you could manage a Gallery and *photograph at the same time. Your letter therefore didn't come as a surprise.*[14]

In spite of Adams's disclaimer that he was not trying to imitate Stieglitz, his gallery was undoubtedly inspired by An American Place. The simple gallery space, the straightforward presentation of the works, even the artists whose work was shown, all are reminiscent of the Place. In retrospect, Adams viewed as ludicrous "the idea that I could do the same thing, without being realistic at all, the very little idea of finances or problems involved."[15]

His trip to New York had also resulted in the promise from the Delphic Studio to present his first one-man New York show that fall. The exhibit of fifty photographs in November 1933 was a success according to the letters that he received from the director, Alma Reed: "The exhibition has drawn a magnificent audience—there were 432 persons attending the opening reception. All were thrilled with the photographs."[16]

Several prints sold at $15 each, but Adams was never paid in spite of repeated reminders. He was further irritated that Reed did not for-

ward any of the glowing reviews that she mentioned in her letters. He never saw the complimentary review in *Art News* on November 25, 1933: "Scissors and thread and old shingles, seemingly prosaic in actuality, become strikingly dramatic through his lens";[17] or the review in the *New York Times* on November 19, 1933, by Howard DeVree: "Ansel Adams . . . strikingly captures a world of poetic form. . . . It is masterly stuff."[18]

The show left Adams unsatisfied, still waiting for what he considered a good New York show. Clearly that would only be an exhibition at An American Place. He wrote to Stieglitz the following spring: "I want to give another and more alive exhibit in New York. . . . Where to go? I am not insinuating that I would want you to show my things—wonderful as it would be for me—for I know that if you wanted to show them you would tell me so."[19]

Stieglitz did not offer Adams an exhibit then, but Adams was gaining substantial recognition elsewhere. His trip east resulted in exhibits at the Albright Gallery in Buffalo and the Yale University Art Gallery in New Haven in 1934. The De Young Museum in San Francisco presented his second one-man show in 1935. By the time he was thirty-four years old, he had already had four one-man shows at museums, not to mention exhibits at galleries and participation in numerous group shows.

Adams did not see Stieglitz again for almost three years, but they continued to exchange letters. Adams longed to return to New York and wrote Stieglitz in May of 1935: "I wish I could get east and see you again. My visits with you at An American Place remain my greatest experiences in art—they opened wide and clear horizons."[20]

In May 1935, Adams sent Stieglitz a copy of his newly published *Making a Photograph,* his first book on technique. It sold well and was popular with reviewers. Stieglitz was favorably impressed: "I must let you know what a great pleasure your book has given me. It's so straight and intelligent and heaven knows the world of photography isn't any too intelligent—nor straight either. . . . Once more my congratulations to the book. I have bought a copy & recommend it."[21]

The book had grown out of articles on technique that Adams had written in the early 1930s for periodicals like the *Fortnightly* and *Camera Craft*. It eventually led to the Basic Photo series which Adams wrote in the 1940s and 1950s and which he is now revising under the name the Ansel Adams Photography series.

Adams's name is almost synonymous with superb photographic technique. His craft was self-taught, and he worked hard to perfect it. His early piano instruction had involved hours of daily practice with seemingly endless repetitions of scales, arpeggios, and sixths. He carried this discipline from music to photography, and by 1931 he had

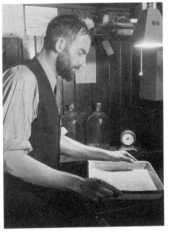

Self-portrait of Adams in his basement darkroom in his San Francisco home, ca. 1936

achieved what he described as "a new photographic technic which I think really amounts to something!!"[22]

Adams claimed that his technique was dependent neither on "encyclopaedic knowledge of optics and chemistry"[23] nor fancy camera equipment. He compared photography to a language and said that in order to communicate you must speak the language fluently. He believed that the mechanics of taking a photograph must be automatic and that technique is merely a means to an end: "We all have our *stresses*—with me it happens to be technique. It's a sort of stock in trade; it really does not relate to what happens inside of me—except to help me to say things a little clearer."[24]

In January 1936, Adams went east as a representative of the Sierra Club. In Washington he testified before Congress on the importance of establishing a national park in the Kings River Canyon area in the southern Sierra. His testimony and photographs helped to eventually persuade Congress to authorize the formation of Kings Canyon National Park in 1937. On the same trip he visited New York. After seeing Stieglitz, he reported joyfully to Virginia Adams:

My Dearest:

Everything seems to come to him who waits!!! . . . I am to have a show at Stieglitz in the fall. Jezuz!!! He is exceedingly pleased with the photographs.[25]

Over the next nine months the exhibition was never far from Adams's thoughts, and letters between him and Stieglitz became increasingly frequent. In July, Adams wrote to Stieglitz from Tyndal Creek high in the Sierra Nevada: "Here I am 11,000 feet up in the air getting some marvelous pictures of peaks and clouds and growing things—some of which may be adequate for the exhibit in October. . . . The show at your place is constantly in my mind—I will do everything I can to make it fine."[26]

In August, after Adams returned from the Sierra Club's annual four-week outing, he started printing for the show. He selected negatives made "in the last five years"[27]—between 1931 and 1936. He recalled that he wanted to show "a cross-section" of his work: "I tried to balance it out."[28] Two-thirds were images that Adams had made in the very early 1930s and exhibited frequently in various one-man shows. Only three were landscapes, and it is important to note that the heroic landscapes like *Moonrise, Hernandez, New Mexico* and *Clearing Winter Storm, Yosemite Valley, California* were not made until the 1940s.

Of the forty-five images he selected for the exhibition, the majority fall into the category of close-ups, such as, a pine cone and eucalyp-

17

tus leaves (Plate 10), a pine branch in snow (Plate 13), or blades of grass on water (Plate 37). There are isolated forms of wood, including juniper trees in the High Sierra (Plates 17 and 36), weathered fences (Plates 18, 19, and 35), even an old wooden windmill (Plate 9). Subjects like entire trees become abstract studies: Plate 23, a description of sunlight on new-fallen snow, and Plate 22, a pattern of snow-covered pines.

There were photographs of man-made objects, like a pair of scissors and thread that Adams photographed in his front yard on a blanket (Plate 32) and a statue of a not-so-friendly lion at the entrance to Sutro Gardens (Plate 45). Anchors and a wrecked ship were studies in the texture of weather-beaten and water-worn metal (Plates 42 and 44).

Adams included photographs of architecture. At Mariposa he photographed the courthouse (Plate 15), isolating the shape of the building against a dark sky with light playing across the clapboard façade. He reduced factory buildings (Plate 5) to a cubist study with the added textural interest of corrugated metal siding. Even in photographs where an entire building is shown, as in Plate 7 of the firehouse or Plate 2 of an old building, Adams is more interested in the texture and detail of their facades than their three-dimensional architectural form.

He included five portraits, but they were not portraits in the conventional sense that explore a sitter's personality. Adams preferred to photograph people in what he calls a "static" way, with no dynamic expression: "I photograph heads as I would photograph sculpture."[29] The head of Annette Rosenshine (Plate 27) relates to the statue of the head of Minerva in Sutro Gardens (Plate 34). The Tressider family members (Plate 24) are similar, in their almost random disposition and scattered glances, to the statues in the museum storeroom (Plate 6).

All of these disparate subjects are typical of the work that Adams did in the early 1930s under the influence of Group $f/64$. Adams had joined with other Bay Area photographers, including Edward Weston and Imogen Cunningham, to found the Group in 1932. They championed straight photography and opposed the soft-focus, romantic work of the pictorialists. Adams later wrote "We wanted to make sharp, clean photographs as a counter-balance to the sticky muck that was going on about us."[30]

But Adams himself had been guilty of producing "sticky muck" around 1920. He had made romantic photographs with a soft-focus lens, printed on textured papers, and mounted on layered colored paper mounts. In an unpublished manuscript written around 1934, Adams wrote in the third person of his own development:

It is interesting to note that his first work was definitely "pictorial." While he never manipulated his negatives or prints, his compositions

Still Life, San Francisco, California, *ca. 1919, an early photograph by Adams in the pictorial style*

18

were reminiscent of conservative schools of painting, his conceptions slightly tinged with lenient romanticism, and his prints revealed his pleasure in textured papers and impressively expensive presentations. It was not until 1931 that the veil of these relative inessentials was torn away and the emergence of a pure photographic expression and technic was revealed. Almost overnight, as it were, the fussy accoutrements of the pictorialist were discarded for the simple dignity of the glossy print.[31]

The Group placed great emphasis on revealing texture and detail because these were the inherent capabilities of the camera. Adams wrote in an article in *Camera Craft* in 1934: "Photography has certain capacities of expression that none of the other art mediums possess. What I choose to call the microscopic revelation of the lens is perhaps the dominant characteristic of photography."[32]

Leaves (Plate 33) is a typical example of his photographs in the $f/64$ tradition. The subject of plants growing by a bridge conforms to the Group's aim to photograph the world around them, rather than artful compositions in the studio. Adams did not "arrange" the subject other than to rotate his camera on the tripod until he had selected the "best" composition. The plants create a pattern against the dark ground. This tendency to flatten out the picture to create a two-dimensional order is also typical of the Group's work. Every detail of the ferns and grasses is rendered in sharp focus, but the result is almost abstract. Indeed, in 1933 the head of the Art Department at Yale University asked Adams if this photograph showed a tapestry or some other work of art. He was incredulous that such a beautiful image could have been created straight from nature.

Adams wrote of the subject matter that he and the other members of Group $f/64$ selected to photograph: "In the diversity of the subject matter alone one senses the experimental attitude."[33] The Group's meetings provided Adams with a stimulating exchange of ideas with his peers and encouraged him to experiment. He had only embraced photography as his full-time profession in 1930; until then he had studied piano with the intention of pursuing a career in music, and the main source of his income was teaching piano lessons. His work in the early 1930s is experimental in the sense that he was developing his own particular way of "seeing" as well as honing his technique.

After a time Adams felt that the Group was too rigid. In 1935 he wrote an article for *Camera Craft* in which he called the work of Group $f/64$ "transitional" and advocated the development by the members of their own individual "aesthetic expression."[34] The three landscapes that he included in his show at the Place (Plates 4, 31, and 38) are characteristic of the direction that he would pursue in his later photography. The

images were made in 1935 or 1936, and with the lowered horizon, they hint at the vast space that Adams was to create in his heroic landscapes of the 1940s. They are different from typical $f/64$ landscapes like those in Plates 3 or 43. In the former, a view of Half Dome made in 1932, Adams closes off the vista with the massive form of the 3,000-foot granite cliff. In the latter, he creates a flat pattern of autumn foliage.

Adams worked long hours in the darkroom from mid-August to mid-October to produce prints worthy of hanging in the Place. Their predominant characteristic is a sense of almost palpable light. The importance of light in Adams's work has already been recognized. Nancy Newhall titled her biography of Adams *The Eloquent Light,* and John Szarkowski has written of Adams's photographs: "They are concerned, it seems to me, not with the description of objects—the rocks, trees, and water that are the nominal parts of his pictures—but with the description of the light that they modulate."[35] Adams relies on what he calls "myriad subtle intensities of tone" to create "the play of light upon substance."[36] Unfortunately, reproductions in ink can only simulate the "chords of tone"[37] that Adams achieved in the prints he made for Stieglitz in 1936. While the light is extremely brilliant, the prints cannot be described as "contrasty." Adams has the ability to capture a certain kind of light according to the time of day: dawn light on Mt. Whitney (Plate 31); midday sunlight on the skier (Plate 25); misty light on a rainy day (Plate 2); the gray light of a cold snowy day (Plate 22).

Adams sent the prints off to Stieglitz on October 6th along with a letter in which he said: "The show pleases me very much; it is very 'quiet' in a sense—I have avoided any spectacular qualities."[38] "Quiet is not a word that is used frequently to describe Adams's photographs, nor are "delicate" or "tender," words that Dorothy Norman used to describe the prints when reminiscing about the show.[39] For Adams is best known for the dramatic prints of heroic landscapes that he has made since the late 1940s. Stieglitz and Adams discussed the quality of tenderness on Adams's first visit to New York, and he recalled their discussion in a letter to Stieglitz in October of 1933: "I will always remember what you said about the quality of *tenderness* (it's a rotten word for a deep cosmic quality) in things of art. Tenderness—a sort of elastic appropriation of the essence of things into the essence of yourself into giving of yourself without asking too many intellectual questions, to the resultant combination of essences."[40]

The making of the negative is an unforgettable experience for him. He says that he can vividly recall his feelings at the time he released the shutter, even though he cannot remember such mundane details as the date or the names of his companions. He wrote Stieglitz about printing for the show: "I tried to recreate the experience of making the negative. The pictures seemed to become more intense."[41]

Adams was inspired to achieve such a level of intensity principally because he was printing for Stieglitz, and he knew that any photographs that would hang at the Place would have to measure up to the highest standards. Only because of his excellent photographic technique was he able to communicate that intensity of feeling.

Adams's photographs are often compared with his piano playing, and the correlation between music and his photographs cannot be over-emphasized. Music has exerted a profound influence in Adams's life, and musical analogies have been used to describe his photography. Jules Eichorn, one of Adams's piano students in the late 1920s, describes his piano playing as having a "bell-like" sound and "fantastic tonal quality."[42] Helen LeConte, who hiked with Adams in the Sierra, characterized his playing as "crystal clear—like Bach."[43] The remarkable tonal quality is analogous to the wide range of tones from black to white that Adams captures in his photographs. The "crystal" clarity of his playing can be likened to the sense of light he creates. The sound of a bell ringing reverberates and hangs in the air; Adams's best photographs could be said to have the same characteristic; they are so compelling that they linger in the mind long afterwards.

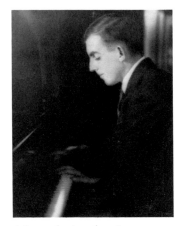

Adams playing the piano, ca. 1922

A comparison of two prints made from the same negative illustrates the evolution of Adams's printing. The negative for *Pine Cone and Eucalyptus Leaves* (Plates 10a and 10b) was made in 1932. Adams made one print in 1933 for his show at the Delphic Studio in New York City; he reprinted the negative again in 1936 for his show at An American Place. The early print is made on Novobrome paper and is characterized by a slightly veiled quality that produces a feeling of softness. The tonal qualities seem subdued, and there is a lack of definition between the leaves, the pine cone, and the background. Adams would now describe this print as "weak," but it is representative of his printing around 1933. The print made in 1936 is very different. It has a crisp light that elucidates every detail of the natural forms. The pine cone and leaves seem "realistic" enough to touch, but it is not so much the image itself that is memorable as the feeling of light and tones.

Adams stresses the fact that much of his success has been the result of long, hard work, based on the discipline he learned as a music student. He feels that the element of "genius," no doubt a necessary ingredient, is overemphasized at the expense of less glamorous hard work. In an article for *Camera Craft* in 1934 he wrote: "It often takes weeks or months to produce the finest possible print from a negative; I frequently make several prints of one subject, mount them, and study them for quite a period of time before making the final print. The ultimate refinements of a photograph are seldom arrived at in the first printing."[44]

Adams wanted the photographs for the Place to be of the highest standards even in terms of their physical presentation. He worried over

21

details of mounts, labels, frames, and even the size of his signature.

The prints were all made on 8 x 10-inch paper as contact prints or very slight enlargements. While Adams's work is known today by 16 x 20-inch prints, until 1960 he usually printed very close to the size of the negative. He did make a few 16 x 20-inch prints in the 1930s, but they are very rare. And even though he experimented with room screens made of panels of photographic paper six feet tall, they were more decorative and functional than creative statements.

For the American Place show he used only one paper: Agfa Brovira Glossy double weight. Although it was introduced to the United States as early as 1930, Adams did not use this paper until 1936. It was characterized by a brilliant luster and fine glossy surface, and it made possible a greater range of tones.

The prints were trimmed and dry mounted on Bristol board that measured 11 x 14 or 14 x 18 inches. Bristol board has a white clay or baryta coating that is lustrous, smooth, and very white. It does not discolor and looks handsome in combination with glossy photographic paper. The prints were mounted with the bottom margin slightly larger than the top.

By 1936, Adams had dropped his middle name, Easton, signing himself simply "Ansel Adams" under the lower right corner of the dry-mounted photograph. For his show at the Place, he used a tiny signature in order not to detract from the small, subtle prints. This was the only time that Adams used such a small signature, and by the early 1940s he had reverted to a larger, more flamboyant signature, sometimes underlined for emphasis.

In the fall of 1936, Lawton Kennedy designed and printed a new label for the back of Adams's photographs as well as new stationery to match. The label is very plain, with Centaur type that Adams still likes today, and a line on which he could type the title of the image. The label was glued to the center back of the mount.

Typical signature, 1936

A
PHOTOGRAPH
BY
ANSEL ADAMS
SAN FRANCISCO

SCISSORS AND THREAD

Label designed in 1936 by Lawton Kennedy for Ansel Adams's photographs

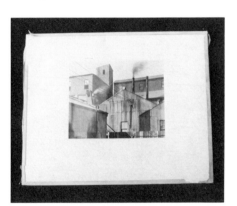

Front and back of Ansel Adams's photograph Factory Building *(Plate 5) in original passe-partout for exhibition at An American Place, by Mariana Cook*

22

Stieglitz suggested that Adams have his photographs "passepartouted" in San Francisco to save money, and Adams had the work done by his framer, the Courvoisier Gallery. Each mounted print was sandwiched between a piece of glass on the front and two pieces of pulp board. The sandwich was held together with white linen tape and had two small rings affixed to the back for hanging. When a photograph was sold, it could be put in a white metal frame like those Stieglitz favored for his own work. Only two photographs, Plate 5 and Plate 36, remained in their original passepartouts until this exhibition necessitated their replacement with strong traveling frames.

Adams's show opened at the Place on October 27th. Naturally, he wanted to see it, but he lacked the time and money to go to New York. His father-in-law had died suddenly in October, and he was faced with the added responsibility of his wife's inherited concession, Best's Studio, in Yosemite National Park. However, a show of fifty of his photographs was also opening at Katharine Kuh's gallery in Chicago on November 2nd, and Kuh wanted him to come to Chicago for the opening. She promised to find him commercial and portrait work there. With the added incentive of the need to negotiate a concessioner's permit with the National Park Service in Washington, Adams had decided to make the trip east. He left San Francisco in early November and proceeded via Chicago to New York. He visited the Place the first morning he arrived, on November 16th.

The physical characteristics of An American Place were not exceptional. The gallery occupied about a quarter of the seventeenth floor at 509 Madison Avenue, at the corner of 53rd Street. The building, erected in 1929, was described as "modern" at the time, with a reserved but handsome exterior and setbacks on the upper floors. The Place was divided into six rooms: three served as galleries and three were used as office and storage space. The interiors were plain. Architectural details were nonexistent. There were no moldings, the nine-foot-nine-inch ceilings were cut by beams, the concrete floor was divided by a square grid pattern, and even the radiators were left bare. Some pipes were exposed that still exist today; the space is now occupied by a design firm.

What made the Place special, aside from the Stieglitz mystique, was an abundance of light. Dorothy Norman has written: "When you enter An American Place, the first thing you sense is the quality of light."[45] Afternoon light poured in the six-foot-tall windows overlooking Madison Avenue to the west, and the white roll-up blinds diffused the light and made the rooms glow. To supplement the daylight, Stieglitz installed a then sophisticated lighting system when he moved into the building in 1929. Slanted metal sheets concealed the light fixtures, which bathed the walls with light. While good lighting in galleries is taken for granted now, it was unusual in 1936. Adams was very

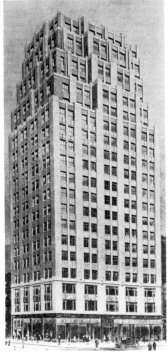

Architect's sketch for 509 Madison Avenue, New York City, where An American Place was located in Room 1710

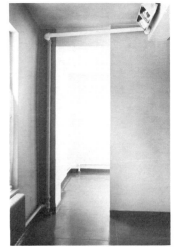

Doorway with exposed pipes in gallery at An American Place, by Ansel Adams, ca. 1939

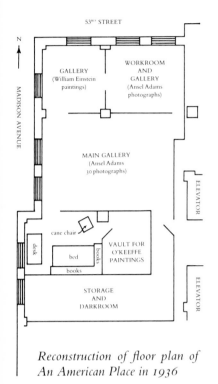

Reconstruction of floor plan of An American Place in 1936

much impressed by the effect and selected the same combination of natural and artificial light for his own home.

Adams's show was hung in two galleries: the main gallery (about 18 x 22 feet) that faced Madison Avenue contained thirty photographs; the smaller gallery (about 12 x 16 feet) overlooking 53rd Street contained the remaining fifteen photographs. The walls were painted a color that Adams describes as "40% cool gray."[46] All of his earlier shows had been hung on white walls, and he was immediately won over to Stieglitz's use of color as a foil for photographs. He wrote to Beaumont Newhall about the Place: "I think the finest walls I have ever seen are in Stieglitz' Place—whatever is on them seems to hold its own life."[47] Even now Adams's home has gray walls on which to display his photographs, and he is disturbed by black-and-white photographs hung on white walls.

Adams remembers that when he walked into his show, he was overwhelmed by the way Stieglitz had hung his work. He wrote immediately to Patricia English, who had assisted him in the darkroom while he was making the prints for the show: "The show was presented in a way that I can never describe. Not only were the prints hung in a visually perfect way, but the hanging actually psychoanalyzed me. The prints were never grouped to achieve culmination of effect or idea—but were related one to the other in such a way that both my strength and weakness were indicated. An American Place is a laboratory—and that is what makes it so exceedingly important."[48]

He wrote to Beaumont Newhall a year and a half later: "He [Stieglitz] knows the importance of subtle juxtaposition of print against print; values are accumulative; the significance of sequence and combination is of the greatest importance to him. . . . It is more than just good hanging—it is the *composition* of values and contents and meanings."[49]

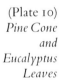

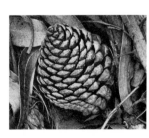

(Plate 10)
*Pine Cone
and
Eucalyptus
Leaves*

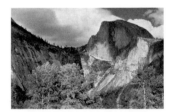

(Plate 3)
Half Dome

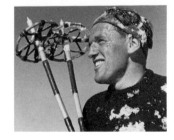

(Plate 25)
Hannes Schroll

24

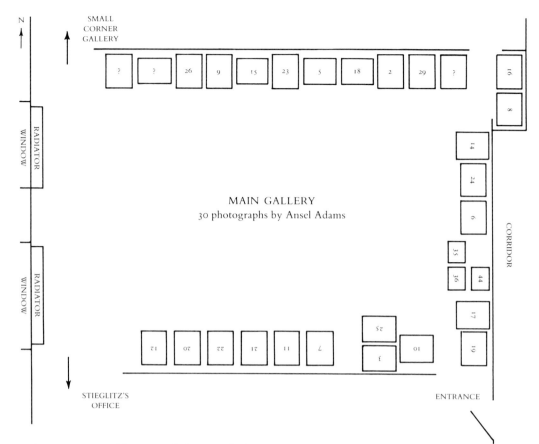

Reconstruction of hanging of photographs by Ansel Adams in main gallery at An American Place, November 1936

The way Stieglitz arranged nine of the photographs on the south wall is typical of the hanging of the show. The first three photographs were a bizarre combination of images: *Pine Cone and Eucalyptus Leaves* (Plate 10), *Half Dome* (Plate 3), and a portrait of Hannes Schroll (Plate 25). Hung together, they encompassed the three phases then current in Adams's work. The photograph of the pine cone is typical of his *f*/64 subject matter and treatment. The image of Half Dome recalls the hundreds of photographs he had made in the Sierra Nevada as much for factual as for creative purposes. And the portrait of Hannes Schroll, an advertising photograph made for the Yosemite Park and Curry Company, represents his commercial work.

The photographs have many points of comparison. They have in common an intense use of light: bright sunshine on the skier that will quickly melt the snow on his hair and sweater; soft, even forest light that bathes the pine cone; and sunlight modulated by clouds on Half Dome. Stieglitz emphasized the great difference in scale by juxtaposing Half Dome with a pine cone. Hannes Schroll's head, viewed from below, is nearly the same size as the baskets on his ski poles. The snap-

shot nature of the Schroll portrait, made with a 35mm Zeiss Contax camera that Adams had been using for less than a year, contrasts with the careful compositions of the still life and Half Dome. There is emphasis on texture: the wet skin of the skier, the scales of the pine cone, the leaves on the poplar trees, and the granite of Half Dome. Round shapes dominate the three compositions, and all are characterized by a two-dimensional quality.

Six vertical photographs followed on the south wall. Three are of man-made subjects and three are of natural objects, subject matter

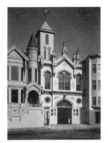 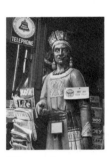 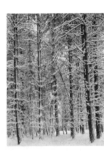 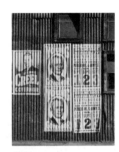 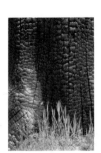

(Plate 7)
Old Firehouse

(Plate 11)
Cottonwood Trunks

(Plate 21)
Americana

(Plate 22)
Winter

(Plate 20)
Political Circus

(Plate 12)
Grass and Burnt Tree

common to Adams's work of the period. All six photographs contain a formal interest in light falling on a flat plane, as in the photograph of the firehouse (Plate 7), or light that creates a mood, as in the photograph of the pine forest in snow (Plate 22). They share the two-dimensional character of the first three images. This quality is achieved by photographing a flat object head-on as in the burnt stump or posters on the wall (Plates 12 and 20) or by using camera position and cropping to create an overall pattern rather than a recession in space as in the photograph of the forest (Plate 22). Attention to detail, characteristic of Group *f*/64, links the images, and there is a juxtaposition of disparate materials such as new grass with burned wood (Plate 12) or paper posters with corrugated metal (Plate 20). Again, actual physical size of the subjects is irrelevant: the tiny new grass (Plate 12) appears to be almost as large as parts of the firehouse (Plate 7), while the scale of the wooden Indian (Plate 21) is the same as that of the pine trees (Plate 22).

The checklist for the exhibition (see page 38) was a single sheet of paper, 9 x 12 inches, folded in three parts. It also announced the show of William Einstein's drawings and paintings on one flap. On the side devoted to Adams's show was a list of the forty-five photographs and a statement by Adams.

Stieglitz had asked Adams "to write a couple of hundred words to state your aims."[50] Adams disliked writing about his photographs and

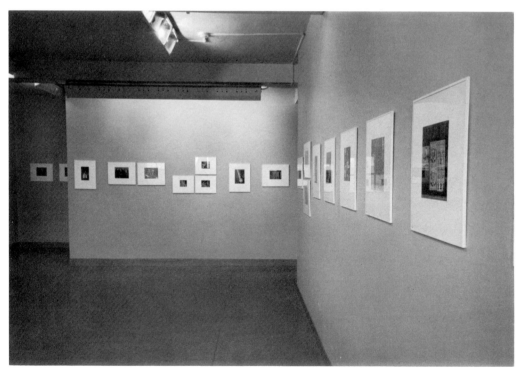

To document the exhibition, Adams photographed the main gallery. The negatives were underexposed and have been printed for the first time for this monograph. The upper photograph shows the east and south walls of the main gallery at An American Place, November 1936. The lower photograph shows the north and east walls.

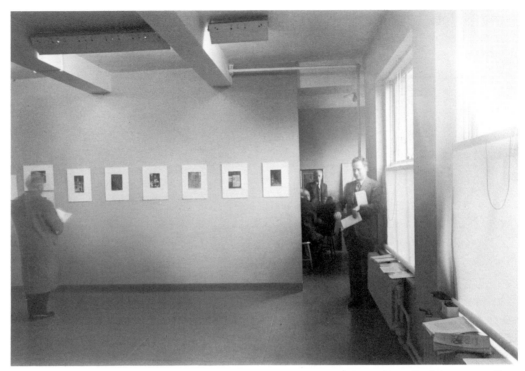

Stieglitz can be seen in his office in this installation photograph of the south wall of the main gallery at An American Place. Checklists for the exhibition can be seen on the radiator, where they were available free of charge.

to this day categorically states that he cannot verbalize on his work. But he wrote what he called an "attempt at a statement"[51] and sent it to Stieglitz with the qualification: "If you don't like it—tear it up. I have a fierce time stating what I feel about anything in words."[52]

Stieglitz thought the statement was "just right."[53] It summed up Adams's belief that a photograph is a communication: "Photography is a way of telling what you feel about what you see." He cautioned that an adequate technique is "quite essential" but that it is only a tool to be used to achieve expression, not an end in itself. And he stressed that his photographs are "individual experiences" translated into black-and-white photographs, a medium that allows "phenomenal clarity and depth," "sonority of tone," and "accuracy of detail and texture." These were central concerns to Group *f*/64, and Adams's statement could easily have been written for an exhibition of their work.

Adams had a difficult time deciding on appropriate prices for his photographs. In his 1933 New York show they had been $15 each, and his usual prices in the early 1930s were in the range of $5 to $15. He wrote to Stieglitz on more than one occasion concerning the subject during the fall of 1936: "As to prices—I am frankly perplexed on that

score. I don't want to charge too much—nor do I want to cheapen the work. I would like to average $20.—to $25.00 for the prints, and will indicate tentative prices on the print list. If you feel the prices are not right, will you use your judgement and alter them to suit you."[54]

The checklist for the show did not include prices, nor were they posted in the galleries. Judging from the correspondence, Stieglitz assigned his own prices taking into account the image, its size, and the buyer. This is supported by a quote by Stieglitz (in other circumstances) about prices for his painters' work taken down by Dorothy Norman in 1935: "They name minimum prices acceptable to them for their pictures at the time of exhibitions. I often ask a good deal more, depending on the circumstances."[55]

In terms of sales, the exhibit was the most successful of Adams's career up to that point. At least nine, probably more, photographs were sold from the exhibit over a period of three months. Adams wrote to his wife on November 16th: "He [Stieglitz] has already sold seven of them—one (The White Tombstone) for $100.00. The others for an average of over $30.00 each."[56] Stieglitz kept no records of sales, but from the letters between him and Adams it is possible to ascertain that David McAlpin bought eight photographs, including *The White Tombstone* (Plate 29), and Mrs. Charles Liebman bought one (Plate 5) for her brother, Walter Meyer.

Stieglitz did not like the idea of "selling" works of art. He preferred to use the verb "place" instead of "sell," and he never used the word "check." He wrote to Adams in December: "I enclose another pleasant missive. I have placed another print. Also a very good party."[57] The "pleasant missive" was a check made out to the artist directly by the buyer, who was also expected to make a contribution towards the expenses of running the gallery. After McAlpin had purchased several more photographs from the show, Stieglitz wrote to Adams: "He [McAlpin] gave Dorothy Norman $49.00 for the Place. So you see you are helping pay rent for the Place. Works all around."[58]

But the sales of photographs were not the most important aspect of the show to Adams. He wrote to Stieglitz: "Not that the sale of the seven pictures was not very nice in a practical way, but—the fact that they were purchased by people to which they will mean something for themselves is the important thing."[59]

And he wrote to David McAlpin the following spring of 1937: "Needless to say, I am very happy that you have enjoyed my pictures. I look back at my exhibit at Stieglitz' with nothing but pleasure; the prints that were sold all went into appreciative hands. The mere fact of someone possessing one of my pictures is nothing compared to the most important fact that the picture means something to the possessor. I hope my photographs will continue to give you pleasure."[60]

The fact that the photographs had gone to McAlpin's "appreciative hands" was of emotional importance to Adams, but the money he received was welcome. He could not support his wife and two children on the sales of his creative work. There were few photography galleries where he could show, and his own gallery had proved unsuccessful. Sales were few and depended on exhibits at museums or the rare show at an art gallery.

Until 1960 the major portion of Adams's income derived from his commercial work. One of his first employers was the Yosemite Park and Curry Company, for whom he made publicity photographs; Plate 25 is an example of the hundreds of photographs he made for them to promote winter sports. He also worked for San Francisco museums, photographing objects in their collections; Plate 6 was made while he was at work photographing a painting in the basement of the De Young Museum. Adams did portrait work too, and the photographs in Plates 24, 26, and 27 were commissions. He was the official photographer for the annual Sierra Club outings for many years. In return for photographing the terrain and making prints available at a nominal fee, he went free of charge. This provided him with the opportunity to photograph over a period of several weeks in the Sierra, and on the 1936 trip he made six negatives that he printed for the show (Plates 1, 2, 17, 31, 36, and 38).

His visit in November 1936 to see his successful show at the Place was possible financially only because of the commercial work that he did on his trips to and from New York. He wrote to Patricia English from Chicago and described the photographs he made for Stein and Co.: "who make Paris Garters, corsets, Brassears (?) etc. . . . We started with some experimental pictures of torsos with elastic corsets. It was a perfectly swell model—one of Steichen's girls."[61]

And from New Mexico he wrote English about his experiences photographing deep underground at Carlsbad Caverns on a commission from the National Park Service: "It was a tough day yesterday, with all the gloomy clouds and the oil in that hole-in-the-ground. Today the elevators were not working in the morning and I carried the camera, tripod, reflector and lights all the way down the trail for the full 750 feet. My shoulders are a bit creaky tonight."[62]

The initial relationship between Ansel Adams and David McAlpin of artist and collector broadened into a deep and lasting friendship. Their mutual admiration and affection for Stieglitz was a common bond. In the early 1940s they worked with Beaumont Newhall to found the first department of photography as a fine art at the Museum of Modern Art in New York. They took trips together to the Southwest and the Sierra, and they carried on a frequent and lively correspondence that continues to this day.

Such jobs were in marked contrast to the euphoria of his creative success at the Place. The press reviewed the show favorably, if not in detail. Howard DeVree made two brief mentions of the show in the *New York Times*. On November 1st he described the show as "some unusually interesting work."[63] And on November 8th he wrote succinctly: "A large selection of photographic work by Ansel Adams is being sponsored by Alfred Stieglitz till Nov. 20 at An American Place—and that is perhaps sufficient commentary on the caliber of the exhibition."[64] Stieglitz wrote Adams that "visitors are not numerous,"[65] and Dorothy Norman recalls that, while the show was not crowded, it was "well liked."[66]

Adams stayed in New York only four days. On November 19th he went to Washington to talk with the National Park Service about Best's Studio in Yosemite. He then returned to New York where he saw his show again before it closed on the 25th. After stopping in Chicago for more commercial work, he finished the trip with a week-long stay in New Mexico to make the photographs of Carlsbad Caverns. He finally arrived in San Francisco around December 10th, more than a month after he had left.

Letters from Stieglitz arrived with news of more sales: "I hope you are pleased as well as surprised. I am. It's all too wonderful. But Lord you deserve it. I know your head won't be turned. And remember just go your own way. Don't let the Place become a Will'O'Wisp. So many have done that. And that's awful all around. Destructive in the worst sense. . . . Well Adams it has been a great experience for me to have had your prints here & to have you here. A truly great one."[67]

And it had been an exhilarating experience for Adams, so much so that a letdown on his return was almost inevitable. He was exhausted both physically and mentally and caught infectious mononeucleosis. After several days in the hospital in December he wrote to Stieglitz: "What happened to me is very hard to describe. For years I have been driving myself beyond reason. . . . The gradual nervous and physical pile-up of exhaustion had to be accounted for. The last trip to New York was a frantic attempt to keep the wheels spinning—and when I arrived home I felt at the breaking-point."[68]

The doctors ordered him to take time off to recuperate, and his convalescence provided the time to reconsider the direction of his life and work. He felt that he was "at a turning point in many things."[69] He yearned to simplify his life, and in an effort to make a change he and Virginia decided to move: "We are moving across the Bay to Berkeley in order to lead a simpler and sunnier life. The house we are renting is up on a hill with lots of Eucalyptus trees and laurel trees and canyons and hilltops all around it. It is a swell place for children to grow up in. . . . San Francisco is a cold and depressing place in many ways."[70]

Adams wanted to curtail his commercial work. Financially, he could not give it up altogether, but he resolved to "concentrate on honest things" and accept only those jobs that he felt were "honest and real."[71] This conflict between the creative and commercial continued until the 1960s when rising sales of his photographs allowed him to give up commercial work.

Inspired by the experience of seeing his work on the walls of the Place and by his visits with Stieglitz, Adams wanted to devote more time to his creative work. He wrote Stieglitz in 1937 that the show had not been his "swan-song"[72] and that his work was moving in new directions: "My own work has suddenly become something new to me—new, and exciting as never before. . . . I can see only one thing to do: make the photography as clean, as decisive, and as honest as possible. It will find its own level."[73]

Adams believed he was progressing with his work and hoped that Stieglitz would give him another show. After only two years had elapsed, in 1939, David McAlpin wrote to Stieglitz on this subject: "There's nothing that would help revitalize Adams more than for you to give him another show. He needs something once in a while to stimulate his zeal for creative work. . . . He's often said that nothing had ever done more for him than preparing for a show. . . . He needs the emotional drive of a specific purpose."[74]

No offer of a show was forthcoming, and McAlpin reported on a meeting with Stieglitz shortly thereafter: "He dropped a little encouragement. 'Maybe Adams will bring something I could show this spring—I can't tell, will have to wait & see.' "[75]

McAlpin continued to pressure Stieglitz and wrote Adams in December 1944: "Stieglitz said 'I'd like to give Adams another show but I can't do it until he brings me another group of fine prints which are better than the 1936 show. He may never produce a finer group than that. . . . Perhaps it was the freshness of his response which produced such a remarkable group.' "[76]

Stieglitz never gave Adams another show, and in 1980 O'Keeffe maintained that this was because Adams had never produced a group of prints to compare with those shown in 1936. Although this was hard for Adams to accept, he claimed that he understood Stieglitz's point: "I agree with him that my first show sounded the Adams note, and that there is no justification to show repetitions of that note no matter how much more in pitch it happens to be now. When the new note is sounded a new show will be in order."[77]

But Adams also believed that he was at fault in not showing Stieglitz more fine work. He continually lamented the fact that commercial work and financial pressures kept him from concentrating on his crea-

tive work and denied him the time to make prints of the quality he had produced in 1936. He wrote to McAlpin in 1941: "Stieglitz has seen only three sets of my pictures since I have known him. . . . Its up to me to show him more; it's entirely my fault that I have failed to pull my stuff together to make a decent group."[78]

Stieglitz's refusal to give Adams a second show was also undoubtedly influenced by his increasing age. His concern with his health became more pronounced, and his complaints grew ever stronger. Dorothy Norman was surprised that he gave Adams and Eliot Porter shows at all. She recorded a conversation with Stieglitz in 1946 that is illuminating: "Young people come in and complain that I no longer exhibit new painters. They do not understand I must start nothing new so that I can at least follow through what I have begun."[79]

Stieglitz died in the same year, on July 16, 1946. After his death, O'Keeffe found Adams's unsold photographs at the Place and asked about their disposition. Adams wrote to McAlpin: "I could not think of selling those prints. They should go to those who might enjoy them —you, O'Keeffe, Norman, Newhalls, Henwar, etc."[80]

O'Keeffe added two photographs (Plates 9 and 20) to the six that Stieglitz had acquired from the show (Plates 1, 21, 22, 24, 39, and 43). Then she let Adams's friends make selections. McAlpin chose one (Plate 42) and described to Adams his visit to the Place in March 1947:

> O'Keeffe called up yesterday to say that she had reached the appropriate point for us to come over and take a look at your prints at the Place. So I presented myself this morning. It was quite an experience. . . . I had not seen these prints since the 1936 show. They still stand up mighty fine. . . . Of course, I should not have been surprised as we regard the ones we selected from the same show as Classics and still have them on the Walls at 24 West 55th Street where they continue to attract critical attention and admiration. . . . After most careful deliberation I selected the print—unframed—of the anchors. It is a beauty and I do not have anything just like it.[81]

The Newhalls chose three prints (Plates 15, 35, and 36) the following day, and Nancy Newhall wrote to Adams:

> We accepted your generosity to the extent of adding three to our collection, and they are now hanging on the wall. One is the Mariposa courthouse, against the black sky. The others are little jewels—one of a picket fence and the other a perfect pair to it with similar forms but of weathered wood. These little prints grow upon us and we are delighted to have them.

33

While we were picking out the prints over at the Place Marin came in and was so interested in the prints that Georgia offered him one. We knew that you would be pleased. He chose one of the German-language gravestone series and the Museum Basement picture, too. [Plates 6 and 40][82]

O'Keeffe thought that the eleven remaining photographs should go to the Museum of Modern Art, and Adams agreed. The Museum accepted the gift in November 1947, eleven years to the month after the closing of Adams's show at the Place.

The importance of Adams's show at An American Place goes beyond the outward recognition that he received at the time, the newspaper reviews and the sales of prints. While they were welcome both emotionally and financially, they are less important than the show's long-term effects. Adams wrote to Stieglitz in December 1936 after his return from seeing his show at the Place: "I wonder if you can ever know what your showing of my work has done for my whole direction in life? Or what the influences of you and your work, and of Marin, O'Keeffe, etc.?"[83]

Adams was inspired by Stieglitz's absolute honesty, both in his work and in his personal life, and by that of his artists. He responded to their inspiration by dedicating himself "to developing my work within the limits of my capacities."[84] The show at the Place had been a summation of his work in the *f*/64 style, and after 1936 he did not exhibit again most of the images from the show. For instance, *Factory Building* (Plate 5) was not shown after 1936 and has not been reproduced in any of Adams's books published in the 1960s and 1970s, yet it was included in every one of his important one-man shows from 1932 to 1936 as well as reproduced in his book *Making a Photograph* published in 1935. With his technique at a new level of competence based on years of diligent work, and inspired by Stieglitz and the knowledge that he was accepted at the Place, he was ready to tackle the larger world of the landscape that he characterized as "the most difficult subject matter to work with."[85]

Adams's photographs, regardless of their subject matter, are vehicles for the expression of his deepest feelings. He summed up his concept of art in a letter to his friend, Cedric Wright, after his 1936 show: "Art is both love and friendship, and understanding; the desire to give. . . . It is both the taking and giving of beauty, the turning out to the light the inner folds of the awareness of the spirit."[86] What viewers respond to in Adams's photographs, and what Stieglitz must have also found so moving, is precisely this ability to reveal "the inner folds of the awareness of the spirit."

In the photographs that Adams made for his show in 1936 he revealed his deepest feelings about Stieglitz and the Place: "The Place

means more than anything else in photography. . . . It is always wonderful to know that the pattern of perfection exists somewhere."[87] The Place represented for Adams an ideal, a quest for perfection. It also served as a sanctuary from the hectic world in which he lived with its workshops, travel, writing of books, making of photographs, and commercial work. In every letter to Stieglitz, he reiterated his intense desire to visit the Place, and Stieglitz wrote to him in 1943: "If there be such a thing as peace—the Place is that.—Yes you'd love it if you could walk in just now."[88]

But it did not matter whether Adams actually visited the Place or not; he was comforted and reassured by the knowledge that it existed. He wrote to Stieglitz in 1936: "The Place, and all that goes on within it is like coming across a deep pool of clear water in a desert. . . . Whoever drinks from this pool will never be thirsty."[89] Today, long after Stieglitz's death and the closing of An American Place, these memories and ideals nourish and sustain Adams.

NOTES

The majority of the letters cited in the following notes come from two collections: the Collection of American Literature, Beinecke Rare Book and Manuscript Library, Yale University, New Haven, Connecticut, hereafter referred to by the letters YCAL; and the Center for Creative Photography, University of Arizona, Tucson, Arizona, hereafter referred to by the letters CCP. Material from the Ansel Adams Archive at the Center for Creative Photography is further identified by the letters AAA.

1. Letter from Ansel Adams to Andrea Gray, June 23, 1981.
2. Ibid.
3. Interview by Andrea Gray with Ansel Adams, September 1981.
4. Letter from Ansel Adams to Andrea Gray, June 23, 1981.
5. Letter from Virginia Adams to the Adams family, March 29, 1933, AAA/CCP.
6. Letter from Ansel Adams to the Adams family, April 8, 1933, AAA/CCP.
7. Letter from Ansel Adams to Alfred Stieglitz, June 22, 1933, YCAL.
8. Interview by Andrea Gray with Helen LeConte, June 1980.
9. Interview by Andrea Gray with Patricia English Farbman, March 1980.
10. Letter from Ansel Adams to Paul Strand, September 12, 1933, AAA/CCP.
11. Interview by Andrea Gray with Ansel Adams, February 1981.
12. Letter from Ansel Adams to Alfred Stieglitz, June 22, 1933, YCAL.
13. Letter from Ansel Adams to Alfred Stieglitz, May 20, 1934, YCAL.
14. Letter from Alfred Stieglitz to Ansel Adams, June 9, 1934, AAA/CCP.
15. Interview by Andrea Gray with Ansel Adams, June 1980.
16. Letter from Alma Reed to Ansel Adams, November 16, 1933, AAA/CCP.
17. J.S., "Ansel Adams," *Art News* 32 (November 25, 1933), p. 8.
18. Howard DeVree, "Other Shows," *New York Times* (November 19, 1933), Section 9, p. 12.
19. Letter from Ansel Adams to Alfred Stieglitz, May 20, 1934, YCAL.

20. Letter from Ansel Adams to Alfred Stieglitz, May 16, 1935, YCAL.
21. Letter from Alfred Stieglitz to Ansel Adams, May 13, 1935, AAA/CCP.
22. Letter from Ansel Adams to Mary Austin, August 10, 1931, The Huntington Library, San Marino, California.
23. Ansel Adams, "Exposition of Technique," *Camera Craft* 41 (January 1934), p. 19.
24. Letter from Ansel Adams to David Hunter McAlpin, February 3, 1941.
25. Letter from Ansel Adams to Virginia Adams, January 17, 1936, AAA/CCP.
26. Letter from Ansel Adams to Alfred Stieglitz, July 20, 1936, YCAL.
27. Statement by Ansel Adams for checklist for the exhibition at An American Place, November 1936.
28. Interview by Andrea Gray with Ansel Adams, June 1980.
29. Ansel Adams, "Portraiture," *Camera Craft* 41 (March 1934), p. 118.
30. Letter from Ansel Adams to David Hunter McAlpin, February 3, 1941.
31. Unpublished manuscript by Ansel Adams, ca. 1934, AAA/CCP.
32. Ansel Adams, "Exposition of Technique," *Camera Craft* 41 (January 1934), p. 20.
33. Unpublished manuscript by Ansel Adams, ca. 1934, AAA/CCP.
34. John Paul Edwards, "Group F:64," *Camera Craft* 41 (March 1935), p. 110. [Statement by Ansel Adams].
35. John Szarkowski, "Introduction," *The Portfolios of Ansel Adams* (Boston: New York Graphic Society, 1977), p. viii.
36. Ansel Adams, "The New Photography," *Modern Photography 1934–35* (London and New York: The Studio Publications, Inc., 1935), p. 16.
37. Ansel Adams, "Landscape," *Camera Craft* 41 (February 1934), p. 74.
38. Letter from Ansel Adams to Alfred Stieglitz, October 6, 1936, YCAL.
39. Interview by Andrea Gray with Dorothy Norman, November 1980.
40. Letter from Ansel Adams to Alfred Stieglitz, October 7, 1933, YCAL.
41. Letter from Ansel Adams to Alfred Stieglitz, October 11, 1936, YCAL.
42. Interview by Andrea Gray with Jules Eichorn, March 1980.
43. Interview by Andrea Gray with Helen LeConte, June 1980.
44. Ansel Adams, "Portraiture," *Camera Craft* 41 (March 1934), p. 116.
45. Dorothy Norman, *Alfred Stieglitz: An American Seer* (Millerton, New York: Aperture, 1973), p. 193.
46. Interview by Andrea Gray with Ansel Adams, June 1980.
47. Letter from Ansel Adams to Beaumont Newhall, July 12, 1939, CCP.
48. Letter from Ansel Adams to Patricia English, November 21, 1936, CCP.
49. Letter from Ansel Adams to Beaumont Newhall, March 15, 1938, CCP.
50. Letter from Alfred Stieglitz to Ansel Adams, September 27, 1936, AAA/CCP.
51. Letter from Ansel Adams to Alfred Stieglitz, October 11, 1936, YCAL.
52. Ibid.
53. Letter from Alfred Stieglitz to Ansel Adams, October 22, 1936, AAA/CCP.
54. Letter from Alfred Stieglitz to Ansel Adams, October 6, 1936, YCAL.
55. Dorothy Norman, *Alfred Stieglitz: An American Seer* (Millerton, New York: Aperture, 1973), p. 207.
56. Letter from Ansel Adams to Virginia Adams, November 16, 1936, AAA/CCP.
57. Letter from Alfred Stieglitz to Ansel Adams, December 21, 1936, AAA/CCP.
58. Letter from Alfred Stieglitz to Ansel Adams, December 16, 1936, AAA/CCP.
59. Letter from Ansel Adams to Alfred Stieglitz, November 29, 1936, YCAL.
60. Letter from Ansel Adams to David Hunter McAlpin, April 23, 1937.
61. Letter from Ansel Adams to Patricia English, November 11, 1936, CCP.
62. Letter from Ansel Adams to Patricia English, December 3, 1936, CCP.

63. Howard DeVree, "A Reviewer's Notebook: Among New Exhibitions," *New York Times* (November 1, 1936), Section 10, p. 9.

64. Howard DeVree, "Through A Lens," *New York Times* (November 8, 1936), Section 10, p. 9.

65. Letter from Alfred Stieglitz to Ansel Adams, November 10, 1936, AAA/CCP.

66. Interview by Andrea Gray with Dorothy Norman, November 1980.

67. Letter from Alfred Stieglitz to Ansel Adams, December 16, 1936, AAA/CCP.

68. Letter from Ansel Adams to Alfred Stieglitz, December 22, 1936, YCAL.

69. Letter from Ansel Adams to Alfred Stieglitz, January 3, 1937, YCAL.

70. Letter from Ansel Adams to Alfred Stieglitz, February 10, 1937, YCAL.

71. Letter from Ansel Adams to Alfred Stieglitz, December 22, 1936, YCAL.

72. Ibid.

73. Letter from Ansel Adams to Alfred Stieglitz, November 29, 1936, YCAL.

74. Letter from David Hunter McAlpin to Alfred Stieglitz, January 7, 1939, YCAL.

75. Letter from David Hunter McAlpin to Ansel Adams, January 26, 1939, AAA/CCP.

76. Letter from David Hunter McAlpin to Ansel Adams, December 1944, AAA/CCP.

77. Letter from Ansel Adams to David Hunter McAlpin, March 1945.

78. Letter from Ansel Adams to David Hunter McAlpin, February 3, 1941.

79. Dorothy Norman, *Alfred Stieglitz: An American Seer* (Millerton, New York: Aperture, 1973), p. 227.

80. Letter from Ansel Adams to David Hunter McAlpin, October 2, 1946. [Henwar Rodakiewicz was a film-maker and friend of Stieglitz whom Adams met at the Place.]

81. Letter from David Hunter McAlpin to Ansel Adams, March 19, 1947, AAA/CCP.

82. Letter from Nancy Newhall to Ansel Adams, March 1947, AAA/CCP.

83. Letter from Ansel Adams to Alfred Stieglitz, December 22, 1936, YCAL.

84. Letter from Ansel Adams to Beaumont Newhall, March 15, 1938, CCP.

85. Ansel Adams, "Landscape," *Camera Craft* 41 (February 1934), p. 72.

86. Letter from Ansel Adams to Cedric Wright, 1937, AAA/CCP.

87. Letter from Ansel Adams to Alfred Stieglitz, May 27, 1940, YCAL.

88. Letter from Alfred Stieglitz to Ansel Adams, November 5, 1943, AAA/CCP.

89. Letter from Ansel Adams to Alfred Stieglitz, November 29, 1936, YCAL.

Ansel Adams

Exhibition of Photographs

October 27–November 25, 1936

AN AMERICAN PLACE

509 Madison Avenue, New York

WEEK DAYS 10 A.M.–6 P.M. SUNDAYS 3–6 P.M.

PHOTOGRAPHY is a way of telling what you feel about what you see. And what you intuitively choose to see is equal in importance to the presentation of how you feel—which is also intuitive. If you have a conscious determination to see certain things in the world you are a potential propagandist; if you trust your intuition as the vital communicative spark between the reality of the world and the reality of yourself, what you tell in the super-reality of your art will have greater impact and verity.

Through a straight application of the medium of photography certain perceptive experiences may be expressed with phenomenal clarity and depth. No medium of art has greater strength in subtlety (or more weakness in mannered or grandiose effects). Appropriate sonority of tone, accuracy of detail and texture, and a pure, unadulterated photographic effect, are the prime requisites of the art of photography.

The intellectual elements are, of course, necessary, but they relate more to generalities and analysis than to the creative moment. Perception, visualization, and execution are rigorously interrelated; each in itself has little meaning. A competent technique is quite essential in photography, and an adequate and precise apparatus also, but without the elements of imaginative vision and taste the most perfect technical photograph is a vacuous shell.

In this exhibit at "An American Place" I have tried to present, in a series of photographs made during the past five years, certain personal experiences with reality. I have made no attempt to symbolize, to intellectualize, or to abstract what I have seen and felt. I offer these photographs to the intelligent and critical spectator only for what I believe they are—individual experiences integrated in black-and-white through the simple medium of the camera.

Ansel Adams

PHOTOGRAPHS

1 Latch and Chain
2 Mineral King, California
3 Half Dome, Yosemite Valley
4 South San Francisco
5 Factory Building
6 Museum Storeroom
7 Old Firehouse, San Francisco
8 White Cross, San Rafael
9 Windmill
10 Pine Cone and Eucalyptus Leaves
11 Cottonwood Trunks
12 Grass and Burned Tree
13 Snow
14 Church, Mariposa, California
15 Courthouse, Mariposa, California
16 Mexican Woman
17 Detail, Dead Tree, Sierra Nevada
18 Fence
19 Fence, Halfmoon Bay, California
20 Political Circus
21 Americana
22 Winter, Yosemite Valley
23 Winter, Yosemite Valley
24 Family Portrait
25 Hannes Schroll, Yosemite (Advertising Photograph)
26 Phyllis Bottome
27 Annette Rosenshine
28 Tombstone Ornament
29 Early California Gravestone
30 Architecture, Early California Cemetery
31 Mount Whitney, California
32 Scissors and Thread
33 Leaves
34 Sutro Gardens
35 Picket Fence
36 Tree Detail, Sierra Nevada
37 Grass and Water
38 Clouds, Sierra Nevada
39 Architecture, Early California Cemetery
40 Early California Gravestone
41 Early California Gravestone
42 Anchors
43 Autumn, Yosemite Valley
44 Steel and Stone (Shipwreck Detail)
45 Sutro Gardens, San Francisco (Lion at Entrance)

Facsimile of original checklist for the exhibition, 1936

The Plates

*Interviews by Andrea Gray with Ansel Adams, 1980–81

Latch and Chain, Mineral King, California, 1936

Original exhibition print in the Alfred Stieglitz Collection, the Metropolitan Museum of Art
23.0 x 17.2 cm

Substitute exhibition print, made in 1936, lent by Patricia English Farbman
22.8 x 16.9 cm

Adams made this photograph in July 1936 while he was on the Sierra Club's annual four-week pack trip in the Sierra Nevada. The latch and chain were on the door of a shack in an abandoned gold-mining town near Mineral King, California.

The substitute print was given to Patricia English Farbman by Adams in recognition of her help as his photographic assistant in preparing the show. It was remounted in 1979.

Plate 1

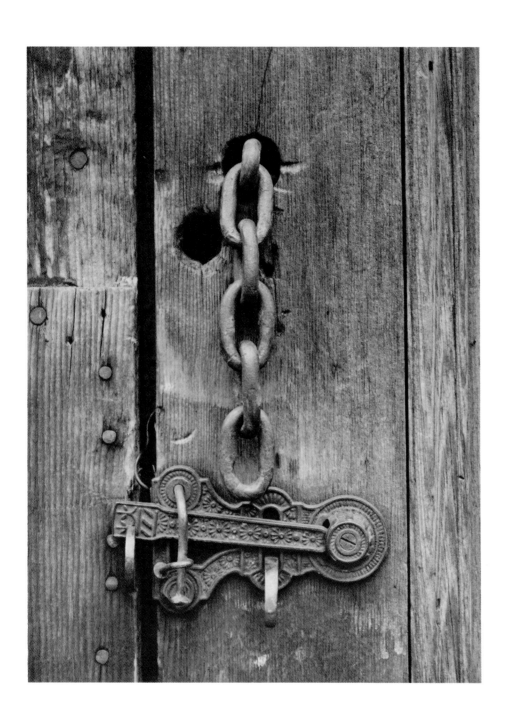

Mineral King, California, **1936**

Original exhibition print lent by the Philadelphia Museum of Art,
 from the Collection of Dorothy Norman
21.4 x 16.8 cm

This photograph was taken on the same day and in the same town as
the previous photograph (Plate 1). Adams recalls that he was attracted
to the "opalescent, moody light"* created by the softly falling rain.

Plate 2

Half Dome, Yosemite Valley, California, 1932

Original exhibition print unidentified

Substitute exhibition print, made ca. 1933, lent by Andrea Gray
15.1 x 23.0 cm

Adams has photographed Half Dome hundreds of times, beginning in
1916 on his first visit to Yosemite National Park. This quiet, straight-
forward portrait of the 4,800-foot granite dome is typical of Adams's
work in the early 1930s in its two-dimensional organization and em-
phasis on texture. Adams set up his camera in a meadow about three
and a half miles away from Half Dome on a late spring day. The poplars
in the foreground were covered with new green leaves.

The original exhibition print has not been found. The substitute
exhibition print was purchased in a thrift shop on Third Avenue in
New York City in the early 1970s. It may be the print that was exhib-
ited at the Delphic Studio in Adams's first one-man show in New
York in 1933.

Plate 3

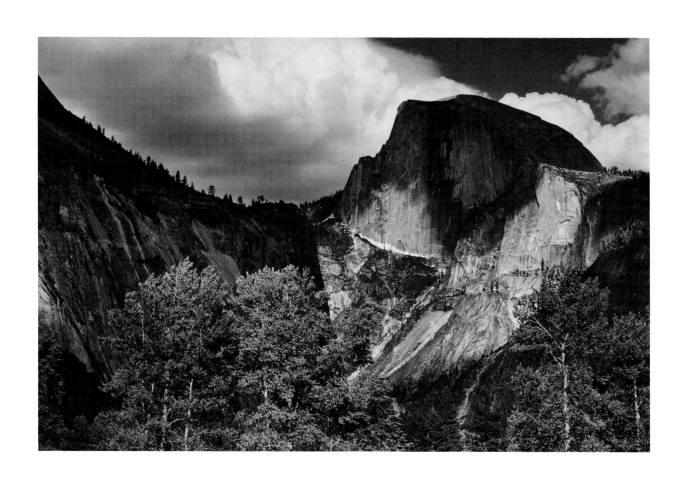

South San Francisco, California, ca. 1936

Original exhibition print lent by the Museum of Modern Art, New
 York, Gift of David Hunter McAlpin
14.1 x 18.8 cm

In the early 1930s, Adams often photographed in the rural area south of
San Francisco, along old Highway 99. The city has since spread south
and engulfed this region of the San Bruno Mountains. The peak in the
center is now known as "Television Peak" because of its present thicket
of television and radio aerials; some early radio aerials can be seen in
this image. This landscape differs from those Adams made in the early
1930s; its lowered horizon and panoramic sweep presage his mature
work of the 1940s.

Plate 4

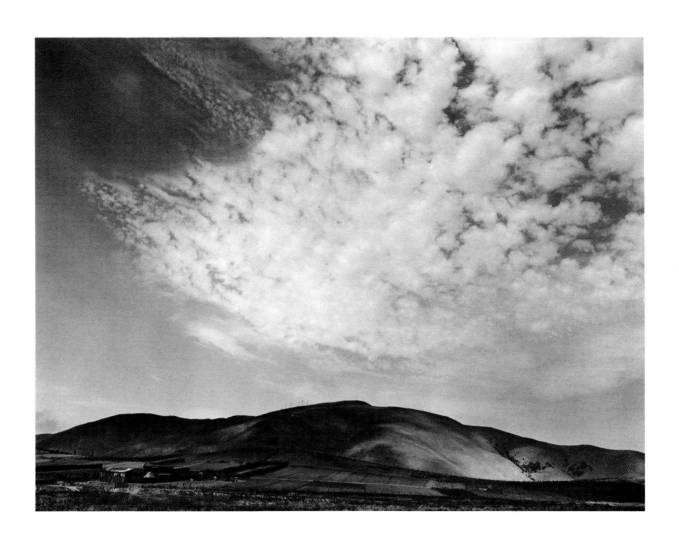

Factory Building, **San Francisco, California, 1932**

Original exhibition print lent by Mariana Cook
18.2 x 23.3 cm

This factory building stood in North Beach near the present Fisherman's Wharf. In making this photograph, Adams recalls that he was "trying to see things accurately and clearly."* Stieglitz admired its "great organization"* when Adams showed him this image on his first visit to New York in April 1933. Katharine Kuh, who exhibited this image in her 1936 Adams show in Chicago, pointed out the interesting juxtaposition of the white smoke against the buildings and the black smoke against the light sky.

The original exhibition print was purchased from the show by Mrs. Charles Liebman as a gift for her son, Walter Meyer. On Meyer's death it passed to his nephew and executor, Dr. John A. Cook, who gave it in turn to his daughter, Mariana. The print was still in its original "passepartout" (see page 22) until 1981 when it was necessary to reframe it for this traveling exhibition.

Plate 5

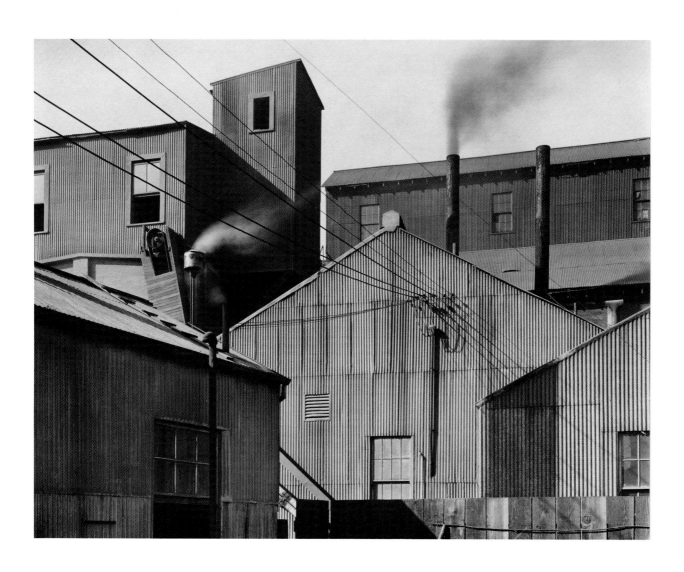

**_Museum Storeroom_, De Young Museum,
San Francisco, California, ca. 1935**

Original exhibition print unidentified

Substitute exhibition print, made ca. 1939, lent by the Museum of
 Modern Art, New York, Gift of Albert M. Bender
18.1 x 23.0 cm

Adams was unable to make a living as a creative photographer, and he
accepted commercial assignments to supplement his income. He often
photographed works of art for the De Young Museum, and he recalls,
"I was photographing a painting in the basement and passed this stor-
age room, saw these statues and decided to photograph them on the
spot."* He remembers that he was attracted by the humor of the plaster
casts relegated to a small basement storeroom. He had to rely on the
dim light available from the ceiling fixtures with a very long exposure.

 In 1947, John Marin chose this photograph from those left at the
Place after Stieglitz's death. His daughter-in-law, Norma Marin, does
not remember if this photograph was in the family collection, and its
whereabouts are unknown. The substitute print was given by Adams
to his first patron, Albert M. Bender, of San Francisco; no other early
prints of this image are known.

Plate 6

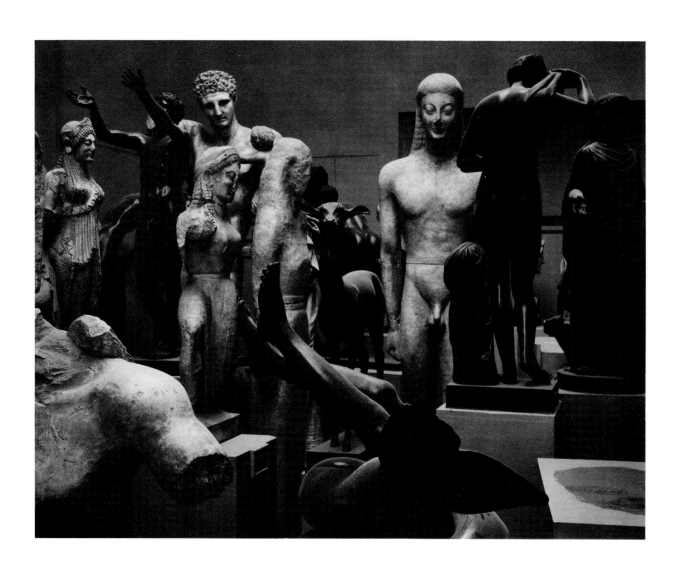

Old Firehouse, San Francisco, California, ca. 1932

Original exhibition print unidentified

Substitute exhibition print, made in 1981, lent by Ansel Adams
23.5 x 17.3 cm

This Victorian firehouse, torn down some years ago, was a familiar sight to Adams on California Street near Divisadero. He passed it every time he took the California Street cable car from his home to downtown San Francisco.

 The location of the original exhibition print is unknown. Because there are no other known prints of this image made in the 1930s, Adams printed the negative for the re-creation of the exhibit.

Plate 7

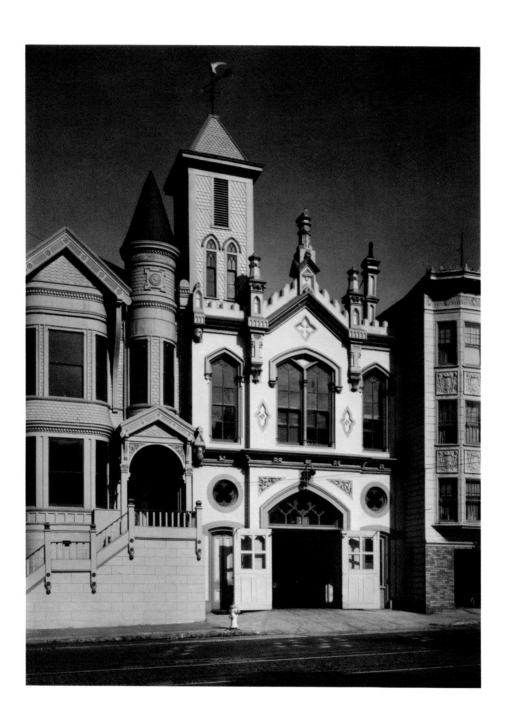

***White Cross, San Rafael*, California, ca. 1936**

Original exhibition print lent by the Museum of Modern Art, New
 York, Gift of David Hunter McAlpin
18.3 x 23.9 cm

This Easter pilgrimage cross stood on the top of a rise near the town of
San Rafael, just north of San Francisco. Adams remembers that he was
struck by the combination of delicate clouds and the very white cross
and drove up specifically to take this picture.* This image has never
been published and was seldom, if ever, exhibited after 1936.

Plate 8

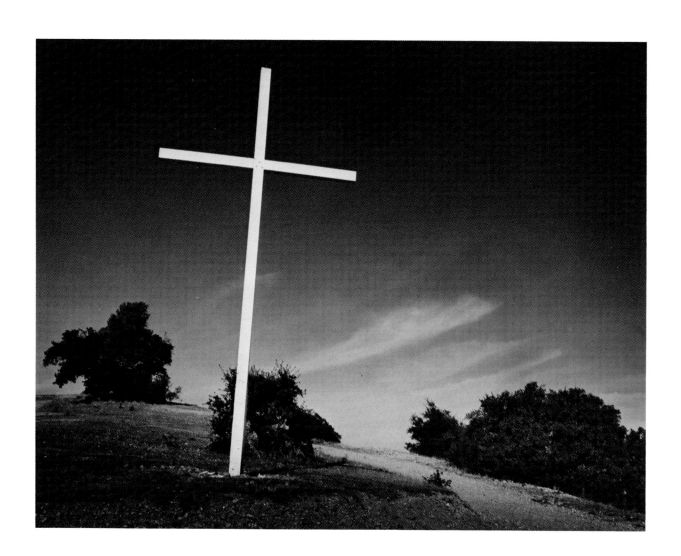

Windmill, **San Francisco, California, 1932**

Original exhibition print in the Alfred Stieglitz Collection, the Metro-
 politan Museum of Art
22.6 x 18.3 cm

Substitute exhibition print, made in 1936, lent by the Art Institute of
 Chicago, Gift of Katharine Kuh
23.2 x 18.3 cm

This windmill stood near the sheds of the Horticultural Center in the
southern part of San Francisco. Adams often photographed in that
vicinity in the early 1930s, and many of his photographs of weathered
wood were made nearby (see Plate 18). Adams says that he noticed the
moon only after he had developed the negative; otherwise he would
have raised the camera to better separate the moon from the sail of the
windmill.* Adams describes this image as one of the first he made in
the *f*/64 style.

 The substitute print was made in the fall of 1936 and exhibited at
the Katharine Kuh Gallery in Chicago in November of that year.

Plate 9

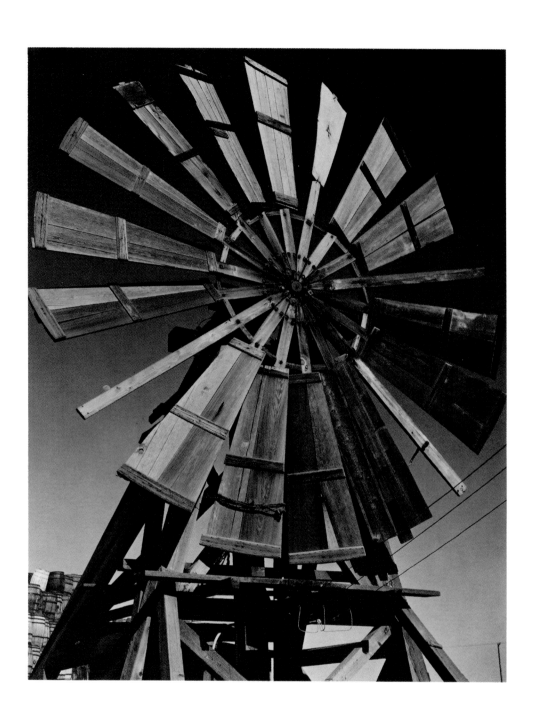

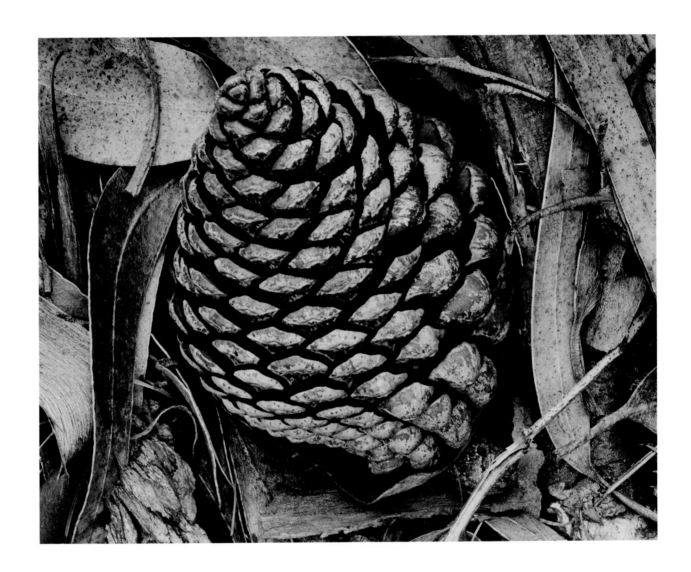

Plates 10a and 10b reproduce two different photographic prints made from the same negative. The print reproduced above (Plate 10a) was made in 1933, while the print reproduced on the opposite page (Plate 10b) was made in 1936. A comparison of the two illustrates the evolution of Adams's printing in the early 1930s. The print from 1933 was made on Novobrome paper and is characterized by a slightly veiled quality that produces a feeling of softness. The print made in 1936 has a crisp light that elucidates every detail.

Plate 10a

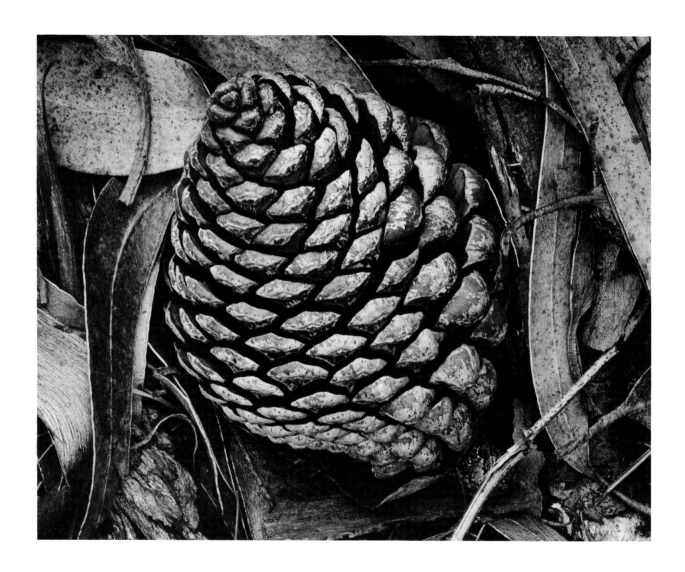

Pine Cone and Eucalyptus Leaves,
San Francisco, California, 1932

Original exhibition print lent by the Museum of Modern Art, New
 York, Gift of Ansel Adams
16.2 x 20.3 cm

Plate 10b

Cottonwood Trunks, Yosemite Valley, California, 1932

Original exhibition print unidentified

Substitute exhibition print, made in 1981, lent by Ansel Adams
23.7 x 18.1 cm

Cottonwoods were once abundant in Yosemite Valley, but they have nearly all disappeared as a result of a drop in the water table about 1870. The groves of dead tree trunks in the meadows of Yosemite Valley were a familiar sight to Adams, and he made many photographs of them. This particular image was included in three of his important exhibits in the 1930s but it was not exhibited again after 1936, and it has never been reproduced. Because there are no known prints of this image, Adams printed the negative for the re-creation of the show.

Plate 11

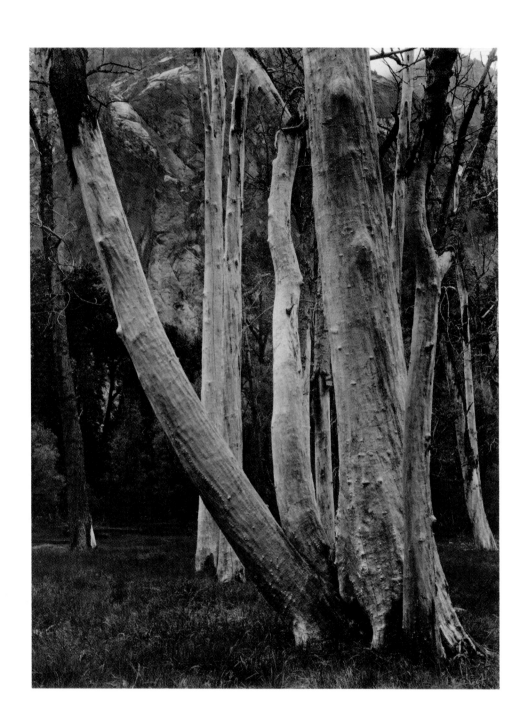

***Grass and Burnt Tree,* Sierra Nevada, California, 1935**

Original exhibition print unidentified

Substitute exhibition print, made in 1936, lent by the Art Institute of
 Chicago, Gift of Katharine Kuh
21.8 x 14.6 cm

Adams made this image near Fish Camp just south of Yosemite Na-
tional Park. A forest fire swept the area many years before, and Adams
recalls that "all around that part of the country you see burnt trees and
stumps."* Adams combined burned wood with tender new shoots of
grass; such juxtaposition of subjects is characteristic of Group $f/64$.

The substitute print was exhibited at the Katharine Kuh Gallery in
Chicago in November 1936 and is now in the collection of the Art
Institute of Chicago. They own another print of this image, made about
1935, given by Adams to Stieglitz, perhaps in January 1936 when he
offered Adams a show. The earlier print is not as brilliant as that made
in 1936, reflecting the advance in Adams's printing in only one year.

Plate 12

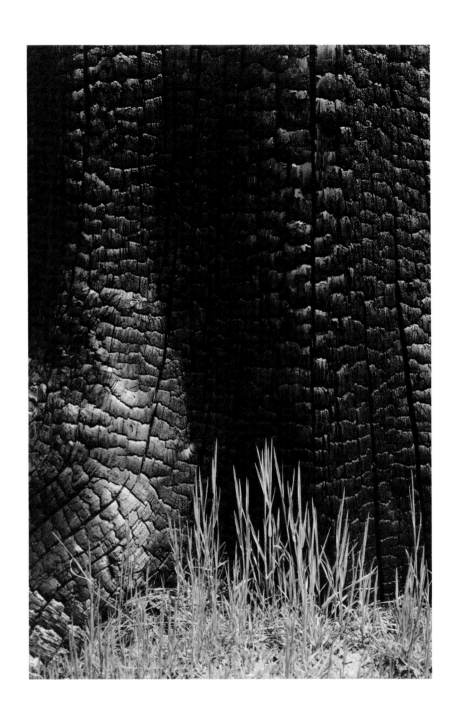

***Snow* [Pine Branch in Snow],
Yosemite Valley, California, ca. 1932**

Original exhibition print lent by the Philadelphia Museum of Art,
 from the Collection of Dorothy Norman
18.8 x 13.2 cm

Adams photographed this branch on the same day that he photo-
graphed the trees in Plate 22. Titling the photograph simply *Snow,*
Adams recalls that he wanted to capture the feeling of "light heavi-
ness"* of new-fallen snow on a cold, leaden day in Yosemite Valley.
The success of this image depends on the superb print quality that
Adams was able to achieve. The negative burned in a fire in Adams's
darkroom in the summer of 1937, and this is one of only two known
prints of this image from the original negative.

Plate 13

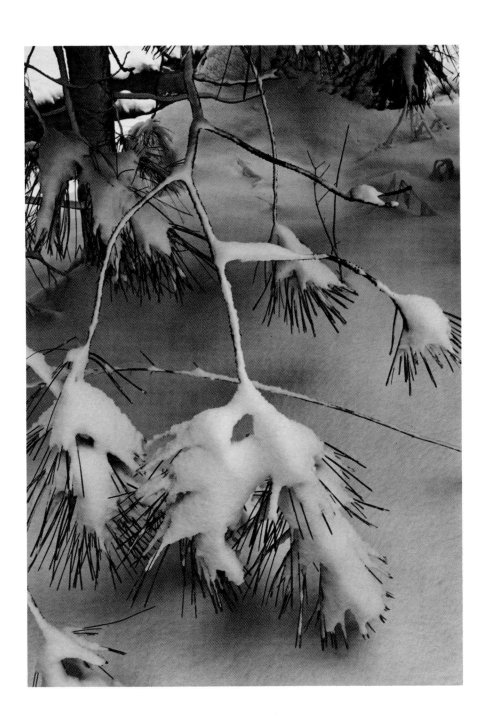

Church, Mariposa, California, ca. 1934

Original exhibition print unidentified

Substitute exhibition print, made in 1936, lent by the Art Institute of
 Chicago, Gift of Katharine Kuh
20.8 x 13.0 cm

The town of Mariposa lies on the main road from San Francisco to
Yosemite Valley, and St. Joseph's Catholic Church sits on a hillside
overlooking the western entrance to the town. Adams travelled fre-
quently from San Francisco to Yosemite, and this church was therefore
a familiar sight. He recalls, "I always liked old churches and ceme-
teries,"* and he photographed this church and its priest, Father Walsh,
on several occasions.

 The original print has not been found. The substitute print was
exhibited at the Katharine Kuh Gallery in Chicago in November 1936.

Plate 14

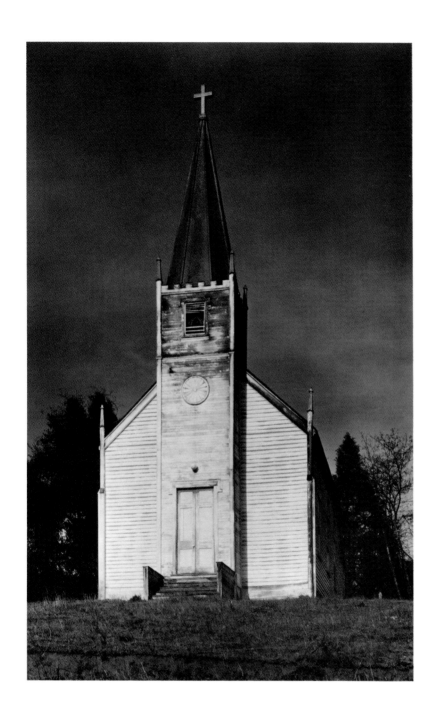

Courthouse, Mariposa, California, ca. 1933

Original exhibition print lent by the Lunn Gallery, Beaumont Newhall
 Collection
17.1 x 22.6 cm

Like the church in the previous photograph (Plate 14), Adams saw this
courthouse often and visited it on family business, even obtaining his
marriage license there in December 1927. Although he photographed
the entire façade, he prefers this close-up.

 Nancy and Beaumont Newhall selected this print from those re-
maining at the Place after Stieglitz's death. It was acquired from their
collection by the Lunn Gallery in 1979.

Plate 15

Mexican Woman, near Snelling, California, 1936

Original exhibition print lent by the Museum of Modern Art, New
 York, Gift of Ansel Adams
16.8 x 20.2 cm

Adams saw an old couple on the porch of a house as he was driving near
the mill town of Snelling, California. He stopped the car to make this
"snapshot" of the woman, using his first 35mm camera, a Zeiss Contax
that he was given by Zeiss in 1935. The images in Plates 24 and 25 were
also made with the Zeiss Contax. Adams had a special label printed for
the back of the photographs made with this camera. It featured the
same design and type as his standard label (see page 22), but it read "A
Zeiss Contax Photograph by Ansel Adams." This variant label was
used on the backs of the three images in the show made with the
35mm camera.

Plate 16

Detail, Dead Tree, Sierra Nevada, California, 1936

Original exhibition print lent by the Princeton University Art Museum,
 Gift of David Hunter McAlpin
23.0 x 16.6 cm

This detail of a juniper tree shows a "boll" where the bark has peeled
away. In his years hiking in the Sierra, Adams photographed many
juniper trees. This particular image was made on the annual Sierra
Club outing of 1936 when Adams also made the images reproduced
in Plates 1, 2, 31, 36, and 38.

Plate 17

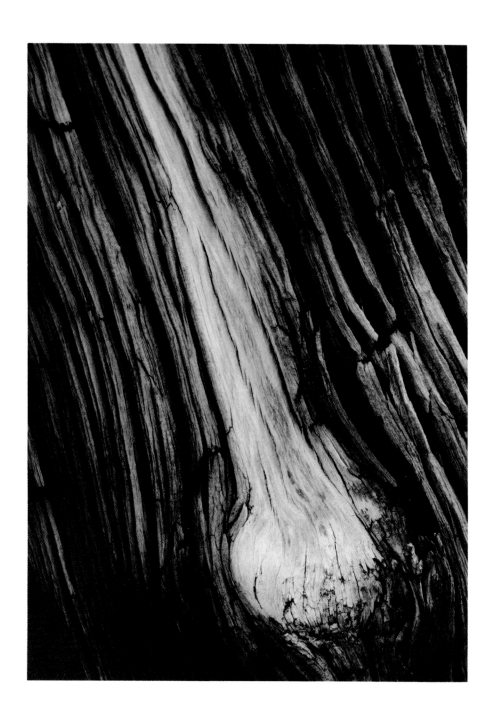

Fence, South San Francisco, California, 1932

Original exhibition print lent by the Museum of Modern Art, New
 York, Gift of Ansel Adams
17.7 x 22.8 cm

Weathered wood was a favorite subject for the photographers in Group
f/64, and Adams made photographs of wooden fences, details of trees
(as in the preceding photograph), and wooden objects (like the wind-
mill in Plate 9). He included photographs of three wooden fences in his
show at the Place: this image and those reproduced in Plates 19 and 35.
Adams recalls that he was attracted to this particular stretch of fence be-
cause of the peeling paint and the texture of the wood illuminated by
full sunlight.* His most well-known photograph of a fence, entitled
Boards and Thistles, was made the same year but just to the right of the
spot where this image was made.

Plate 18

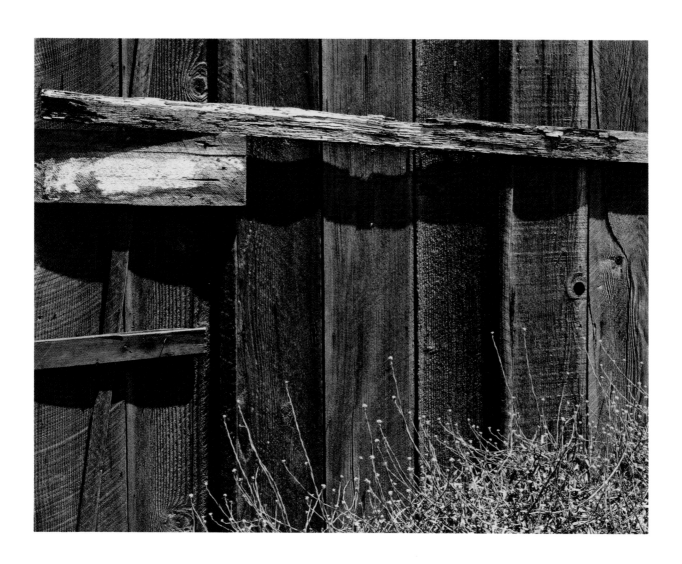

Fence near Tomales Bay, *California*, 1936

Original exhibition print lent by the Museum of Modern Art, New
 York, Gift of Ansel Adams
15.2 x 20.2 cm

On March 15, 1936, Adams wrote Stieglitz about this image: "I have
done one good photograph since my return [from New York in
January] which I think you will like. It is a rather static picture of a
fence—the pickets covered with moss—and dark rolling hills moving
beyond it."[†]
 In the list of photographs for his exhibit at the Place, Adams iden-
tified the site of this photograph as Halfmoon Bay, which is south of
San Francisco. He now thinks that he was mistaken and identifies the
area as near Tomales Bay, north of San Francisco.

[†]Letter from Ansel Adams to Alfred Stieglitz, March 15, 1936, YCAL.

Plate 19

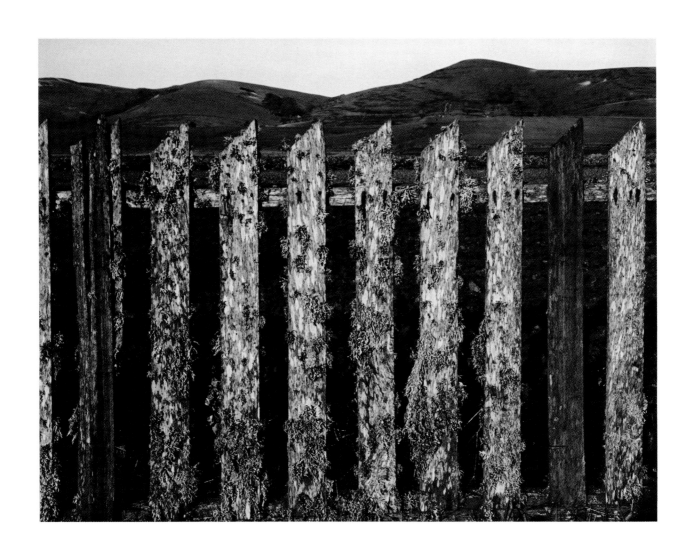

Political Circus **[Political and Circus Posters],**
San Francisco, California, 1932

Original exhibition print in the Alfred Stieglitz Collection, Metropoli-
 tan Museum of Art
23.5 x 17.8 cm

Substitute exhibition print, made ca. 1935, lent by Ansel Adams
23.0 x 18.4 cm

Adams recalls that he was attracted to this subject by the ironic jux-
taposition of posters for the circus and political candidates*: the title
that he used for this image in the 1930s, *Political Circus,* reinforces the
humor of the situation. Adams also makes a virtue of the contrast be-
tween the paper and the metal, highlighted by strong sunlight that casts
shadows on the corrugated metal siding similar to that in the photo-
graph of the factory buildings (Plate 5).
 A vintage print from Adams's collection, the only other known
print from this negative made in the 1930s, was mounted and signed for
this exhibition.

Plate 20

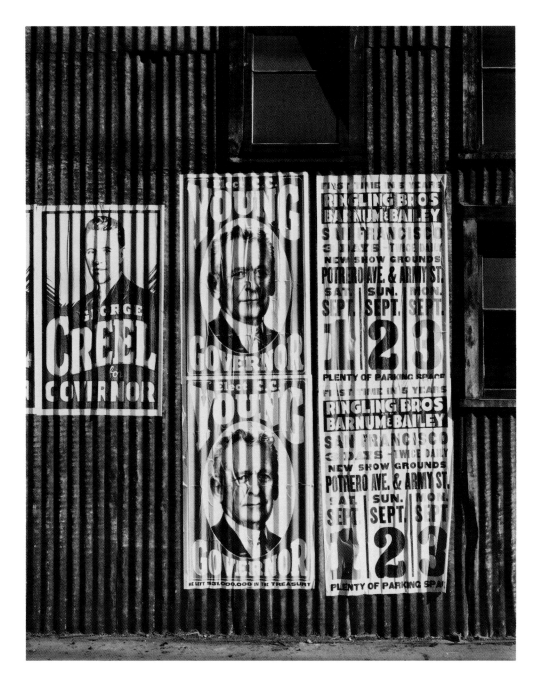

**_Americana_ [Cigar Store Indian],
Powell Street, San Francisco, California, 1933**

Original exhibition print in the Alfred Stieglitz Collection, Metropoli-
 tan Museum of Art
19.9 x 15.2 cm

Substitute exhibition print, made ca. 1960, lent by Ansel Adams
19.9 x 15.2 cm

This wooden Indian stood outside a drugstore on Powell Street in
downtown San Francisco. Adams remembers that he "stopped traf-
fic"* with his tripod on the sidewalk while he made this photograph.
The New Yorker on the magazine rack, dated October 7, 1933, pro-
vides a specific date for this negative, which is unusual for Adams's
work.

 In general, Adams prefers straightforward titles for his photo-
graphs. He infrequently deviated from this policy in the 1930s, as in
this instance where he used the title _Americana_. At one time he envi-
sioned doing a series of such WPA images.

Plate 21

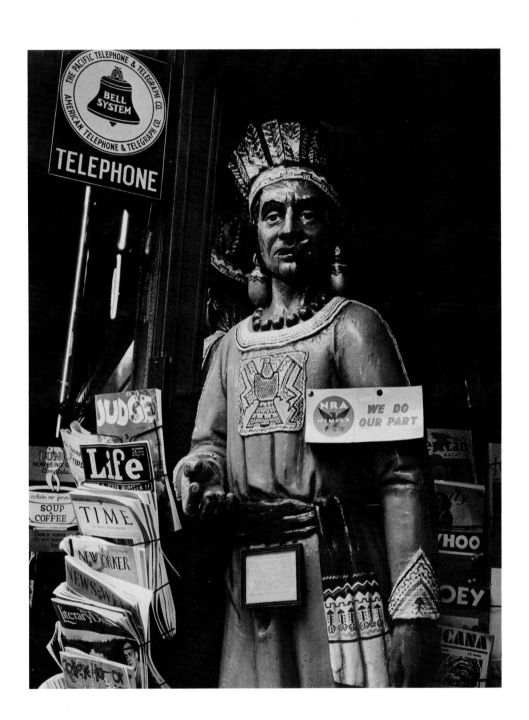

Winter [Pine Forest in Snow], *Yosemite Valley,*
California, ca. 1932

Original exhibition print in the Alfred Stieglitz Collection, Metropoli-
 tan Museum of Art
23.4 x 18.5 cm

Substitute exhibition print, made in 1981, lent by Ansel Adams
23.0 x 17.0 cm

This photograph was made after a new snowfall on the same day as *Pine
Branch in Snow* (Plate 13). Adams recalls that he made the photograph
from the side of the road in the eastern part of Yosemite Valley. The
flat pattern that he created from the snow-covered branches is typical
of the work of Group *f*/64 in its abstraction and two-dimensionality.

 There are no other known prints made in the 1930s from this nega-
tive. Adams made a new print in 1981 for inclusion in the re-creation
of the exhibit.

Plate 22

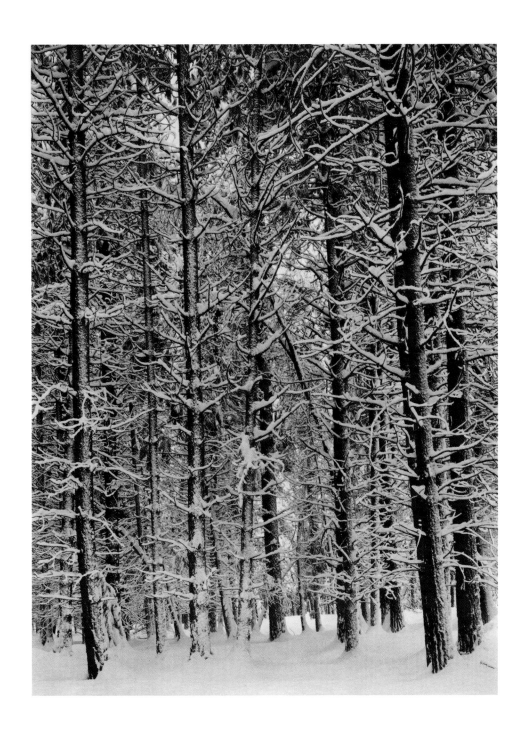

Winter [Oak Tree in Snow], *Yosemite Valley,*
California, ca. 1933

Original exhibition print lent by the Princeton University Art Museum,
 Gift of David Hunter McAlpin
21.5 x 15.2 cm

When Adams first saw Yosemite Valley with snow in April 1920, he
wrote to his family: "I wouldn't have missed this for the world and
consider it the finest season I have seen at Yosemite."[†] He conveys the
effect of brilliant sunlight sparkling on new-fallen snow on this oak
tree that once stood near the granite cliffs of the Cathedral Rocks (just
visible in the background). In an article on landscape for *Camera Craft*
in 1934, Adams wrote of the difficulty of photographing snow: "Per-
haps snow subjects offer the most exasperating problems to be found
in all landscape photography. The photographer is confronted with
extremes of tonal values, and a minimum of texture."[‡]

[†]Letter from Ansel Adams to Adams family, April 1920, AAA/CCP.
[‡]Ansel Adams, "An Exposition of My Photographic Technique: Landscape," *Camera
 Craft* 41 (February 1934), p. 76.

Plate 23

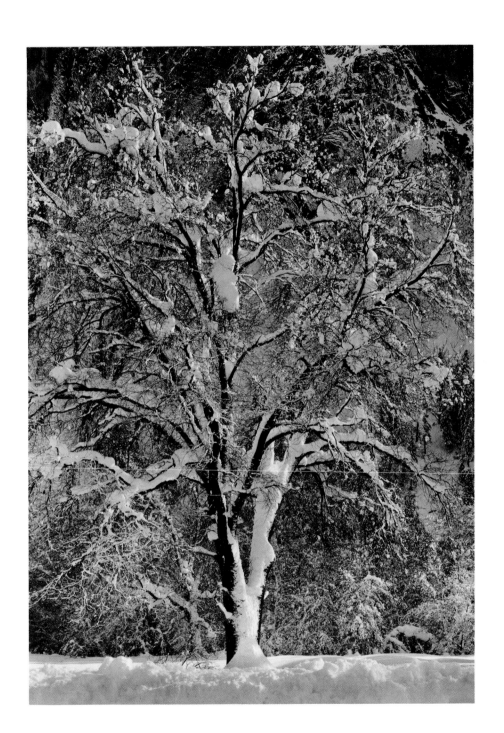

Family Portrait, **Ahwahnee Hotel,
Yosemite Valley, California, ca. 1935**

Original exhibition print in the Alfred Stieglitz Collection, Metropoli-
 tan Museum of Art
17.9 x 23.3 cm

Substitute exhibition print, made in 1936, lent by the Art Institute of
 Chicago, Gift of Katharine Kuh
17.5 x 23.1 cm

Don Tressider, the head of the Yosemite Park and Curry Company,
asked Adams to photograph members of his family who were visiting
in California from the Middle West. Adams photographed them on the
covered porch in Tressider's sixth floor suite at the Ahwahnee Hotel,
using his newly acquired 35mm Zeiss Contax camera. According to
Oliene Mintzer, Tressider's sister, each family member felt that his par-
ticular portrait was not a flattering or faithful likeness, yet each consid-
ered the others to be extremely accurate.

Plate 24

Hannes Schroll, Yosemite Valley, California, ca. 1935

Original exhibition print lent by the Museum of Modern Art, New
 York, Gift of Ansel Adams
18.1 x 22.9 cm

In the title that Adams supplied to Stieglitz for this photograph he
included in parentheses the words "Advertising Photograph." Adams
made this photograph of a ski instructor for the Yosemite Park and
Curry Company as a commercial assignment. While he felt it was of
sufficient quality to include in the exhibit, he also felt it necessary to
make the distinction. Adams marked this portrait and three others in
the show (Plates 24, 26, and 27) "not for sale" because he believed that
it was inappropriate to sell commissioned portraits.

 Adams wrote an article for *Camera Craft* in 1936 entitled "My First
Ten Weeks with a Contax." This portrait of Hannes Schroll was repro-
duced in that article, and it aptly illustrates Adams's main point in the
piece that "the [35mm] camera is for life and for people, the swift and
intense moments of existence."[†]

[†]Ansel Adams, "My First Ten Weeks with a Contax," *Camera Craft* 43 (January 1936),
 p. 16.

Plate 25

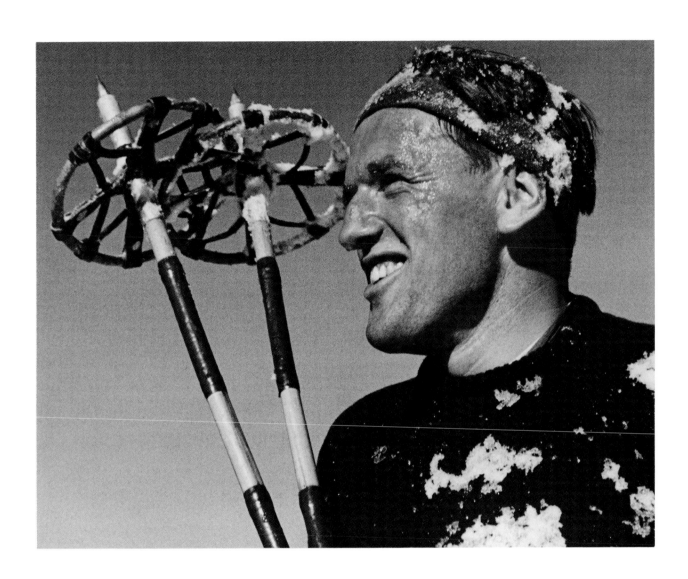

Phyllis Bottome, San Francisco, California, ca. 1932

Original exhibition print lent by the Museum of Modern Art, New
 York, Gift of Ansel Adams
18.2 x 13.0 cm

Bottome was an English writer and novelist who toured America in the
early 1930s and asked Adams to take her portrait while she was in San
Francisco. In her autobiography, *The Goal,* she reproduced this portrait
with the caption: "Photograph of the author taken in 1938 in California
by Adams, which Gertrude Atherton always referred to as 'that God-
awful thing of you.' "[†]

[†]Phyllis Bottome, *The Goal* (New York: Vanguard Press, 1963), caption with Plate 5.

Plate 26

Annette Rosenshine, San Francisco, California, 1932

Original exhibition print lent by the Museum of Modern Art, New
 York, Gift of Ansel Adams
19.2 x 14.4 cm

Rosenshine was a sculptor who lived in San Francisco and met Adams
through Albert M. Bender, their patron. She asked Adams to make a
photograph that she could use as her official portrait, and he made this
profile in his studio using foil-filled flash globes.

Plate 27

***Tombstone Ornament,* Laurel Hill Cemetery,
San Francisco, California, ca. 1936**

Original exhibition print lent by Mr. and Mrs. Wilhelmus B. Bryan III
18.7 x 18.8 cm

David McAlpin purchased this photograph from the show and gave it
to Professor Clifton R. Hall of Princeton University. The print was
framed in a narrow white metal molding like that Stieglitz preferred for
his own work. On the back of the framed photograph McAlpin wrote:
"To Beppo—Stieglitz and I feel that photography deserves a place in
your collection and in your esteem along with Dürer, Rembrandt,
Picasso, Cezanne, and Marin. Here's one of the finest examples of artis-
tic feeling and craftsmanship I ever hope to see. Warmest regards, Dave
McAlpin, Christmas 1936." Steiglitz added below: "I am in perfect ac-
cord with above. My best wishes also. Stieglitz." Professor Hall gave
the print to Mrs. Wilhelmus B. Bryan, who bequeathed it to her son,
Wilhelmus B. Bryan III.

Plate 28

Early California Gravestone, **Laurel Hill Cemetery,
San Francisco, California, ca. 1936**

Original exhibition print lent by the Museum of Modern Art, New
 York, Gift of David Hunter McAlpin
20.8 x 16.2 cm

This gravestone for Lucy Ellen Darcy, who died in August 1860 at
twenty-six years of age, stood inside a fenced plot at Laurel Hill Ceme-
tery in San Francisco. Adams photographed there often in the mid-
1930s, and all the photographs of gravestones and cemetery architec-
ture in his show at the Place were made at Laurel Hill around the same
time. The cemetery was demolished in the late 1930s as the city spread
west, and Adams has in his garden today several gravestones and
carved stone tomb details that he collected during the course of its
demolition.

　　Adams refers to this image as "The White Gravestone." Stieglitz
sold this photograph to David McAlpin for the princely sum of $100.
This was the highest price for any photograph in Adams's exhibit, the
median price having been $25.

Plate 29

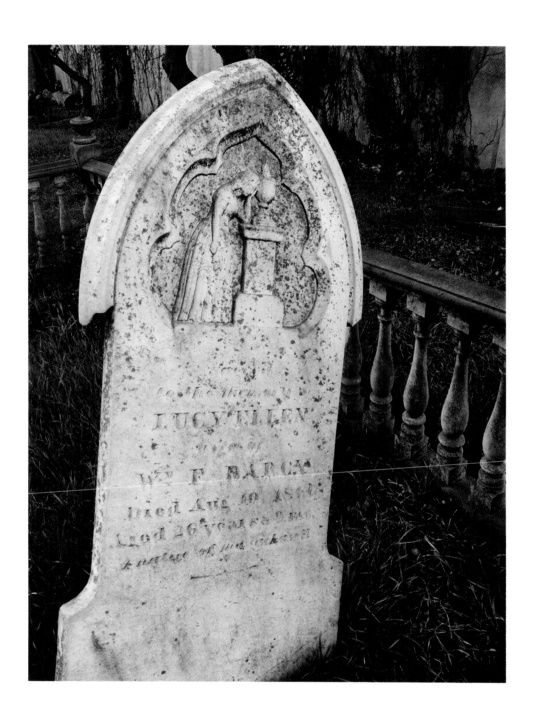

Architecture, Laurel Hill Cemetery, San Francisco, California, ca. 1936

Original exhibition print lent by the Museum of Modern Art, New York, Gift of Ansel Adams
14.8 x 18.7 cm

Although Adams has made hundreds of photographs of tombs at Laurel Hill, most of them are unpublished and few have been exhibited. Laurel Hill offered innumerable subjects for an $f/64$ photographer, including tombs like this and many early gravestones, and it had the added virtue of being very close to Adams's home. Patricia English Farbman, who was Adams's assistant in 1936, remembers that he might suddenly say, "Let's go make photographs,"[†] and they would invariably go to Laurel Hill.

[†]Interview by Andrea Gray with Patricia English Farbman, March 1980.

Plate 30

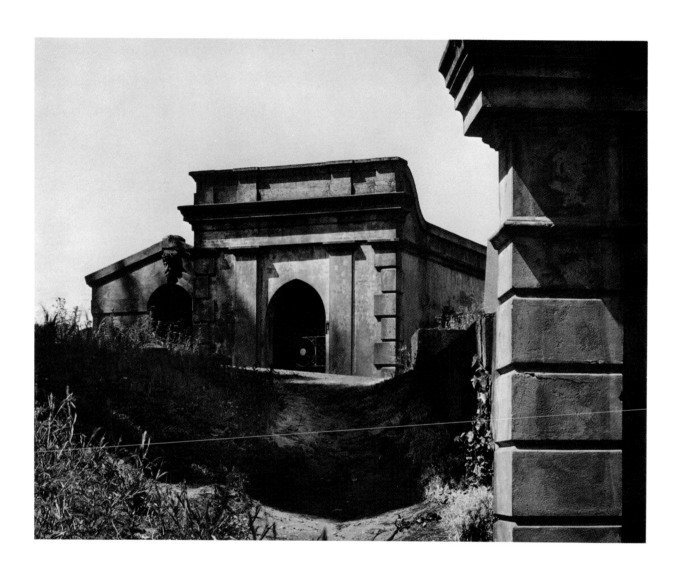

Mount Whitney, Sierra Nevada, California, ca. 1936

Original exhibition print unidentified

Substitute exhibition print, made in 1936, lent by Ansel Adams
11.7 x 14.8 cm

Adams climbed Mount Whitney more than once, and he described it as "very arduous,"* especially when accomplished at night to see the sun rise over the Sierra Nevada. Virginia Adams climbed this peak, too, and she was one of the first women to climb the difficult east slope. Adams made this photograph of the west slope on a Sierra Club outing, probably in the summer of 1936.

The original exhibition print has not been found. Although the substitute exhibition print was most likely made in the fall of 1936, it lacks the sparkle and brilliance that characterize the prints for the original exhibit.

Plate 31

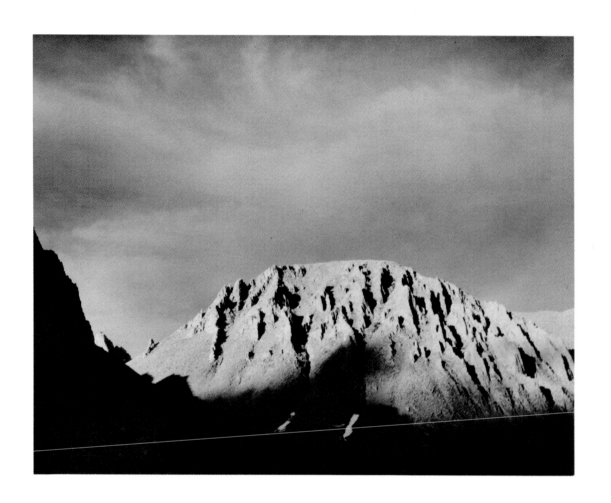

***Scissors and Thread*, San Francisco, California, 1931**

Original exhibition print lent by the Museum of Modern Art, New
 York, Gift of Ansel Adams
21.9 x 11.7 cm

Adams made this photograph on a blanket in the sunny garden outside
his San Francisco home. He remembers dropping the thread several
times before he obtained the desired arrangement.* Although this
photograph was made in 1931, before Adams had joined Group f/64,
it perfectly demonstrates their aim in photography: to create a clean
image of subjects drawn from the everyday world, rendered in sharp
focus with depth of field, attention to detail and texture. Adams in-
cluded this image in an article he wrote for *Camera Craft* in 1934, and it
clearly illustrates what he characterized as "the microscopic revelation
of the lens."[†]

[†]Ansel Adams, "An Exposition of My Photographic Technique," *Camera Craft* 41
 (January 1934), p. 20.

Plate 32

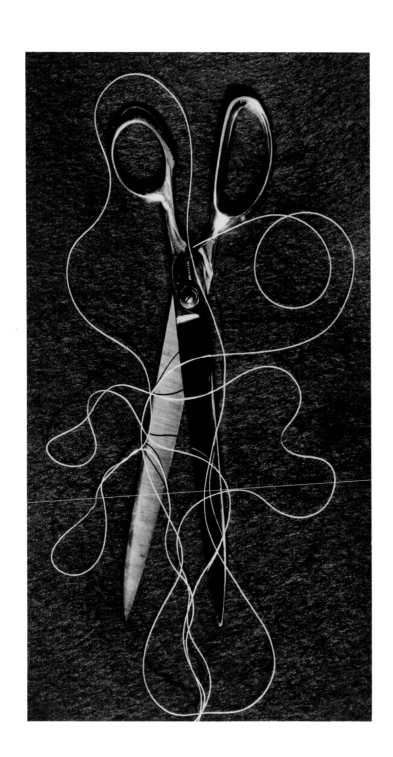

***Leaves,* Mills College, Oakland, California, ca. 1931**

Original exhibition print lent by the Princeton University Art Museum,
 Gift of David Hunter McAlpin
19.1 x 20.9 cm

Mills College is just across the bay from San Francisco by ferry, and
Adams photographed the school for a brochure about 1931. He recalls
that he made this photograph around the same time, looking down
from a bridge over a water course on campus.* He said that the light
"was very subdued and I didn't have a very good meter in those days. I
didn't want it to be dull, but I over-did it; the negative is very difficult
to print. The whites are blocked a bit."*

 Adams made two room screens of this image measuring six feet
tall. The first, made in 1936, was destroyed through mishandling. The
second, made in the mid-1950s, stands in Adams's living room. For
this reason the image is sometimes referred to as "Leaves, Screen
Subject."

Plate 33

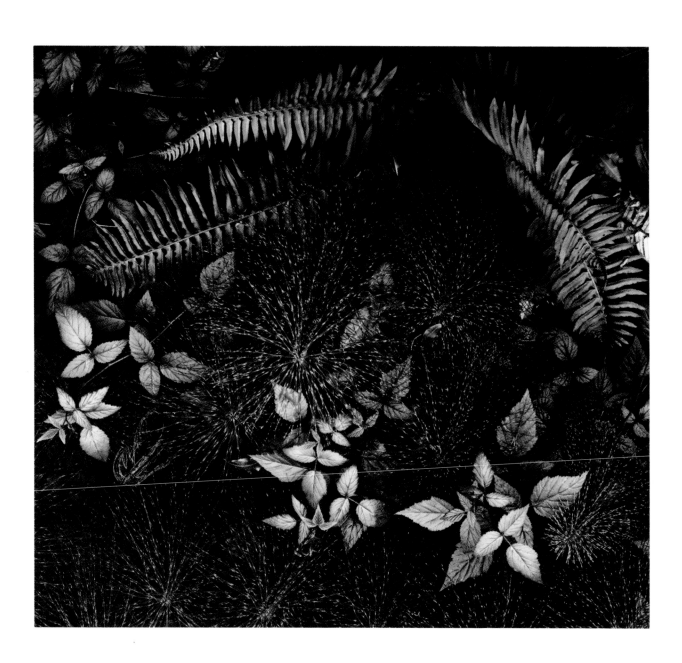

Sutro Gardens, **Head of Minerva,**
San Francisco, California, ca. 1934

Original exhibition print lent by the Museum of Modern Art, New
 York, Gift of Ansel Adams
16.9 x 12.2 cm

Adams often photographed at Sutro Heights overlooking the Pacific,
just west of his home. The gardens there were punctuated with cement
copies of Greek and Roman statuary, and Adams recalls that it was
"quite a mournful place"* in the fog. The photograph of the lion in
Plate 45 was also made there.

Plate 34

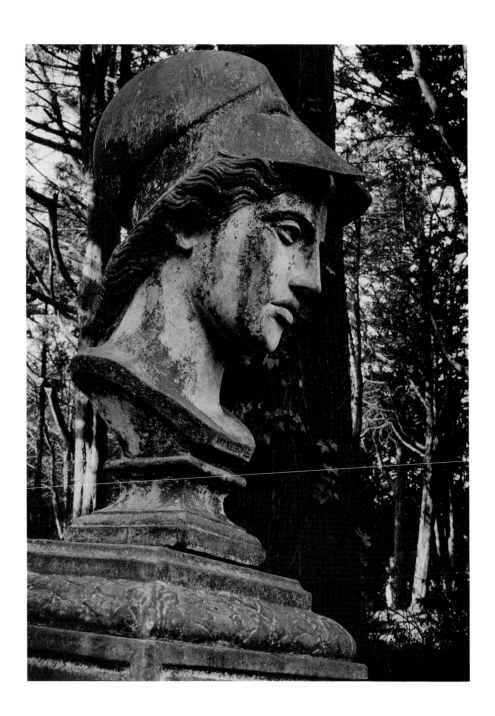

Picket Fence, **Sierra Nevada, California, ca. 1936**

Original exhibition print lent by the Lunn Gallery, Beaumont Newhall
 Collection
10.7 x 11.9 cm

The success of this detail of a wooden fence rests almost exclusively on
the sparkling print quality and sense of light that Adams created, along
with feeling of the texture of the weathered wood and the composition
of the spiked wood members of the fence.

Beaumont and Nancy Newhall chose this print and those in Plates
15 and 36 from the photographs left at the Place after Stieglitz's death.
In a letter to Adams of late March 1947, Nancy Newhall described the
two prints as "little jewels."[†] This photograph was still in its original
passepartout until 1979, when it was acquired by the Lunn Gallery.

[†]Letter from Nancy Newhall to Ansel Adams, late March 1947, AAA/CCP.

Plate 35

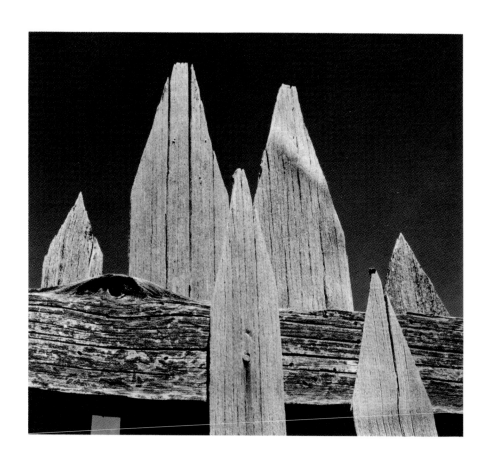

Tree Detail, Sierra Nevada, California, ca. 1936

Original exhibition print lent by the Center for Creative Photography, the Ansel Adams Archive
11.3 x 14.7 cm

Adams has made literally hundreds of close-ups of juniper trees in the Sierra Nevada. This image was probably made while he was on a Sierra Club outing in the summer of 1936.

This print was selected by Beaumont and Nancy Newhall from those left at An American Place after Stieglitz's death. Beaumont Newhall returned it to Adams in 1974, and it is now part of the Ansel Adams Archive at the Center for Creative Photography.

Plate 36

**Grass and Water, Tuolumne Meadows,
Yosemite National Park, California, ca. 1935**

Original exhibition print lent by the Museum of Modern Art, New
 York, Gift of Ansel Adams
11.6 x 14.6 cm

Adams made this photograph at a pool in the Tuolumne Meadows
area. The Sierra Club pack trips set out every summer from Tuolumne
Meadows, and this image may have been made at the beginning of
the trip of 1935 or 1936.

Plate 37

***Clouds, Sierra Nevada,* California, ca. 1936**

Original exhibition print lent by the Museum of Modern Art, New
 York, Gift of David Hunter McAlpin
10.8 x 14.6 cm

Adams made this photograph of the Kern Plateau in the Upper Kern
River Canyon in what is now Sequoia National Park while he was on
the annual Sierra Club outing in 1936. Adams has taken hundreds of
photographs of clouds and peaks in the Sierra, but this is one of his
earliest compositions with a lowered horizon.

Plate 38

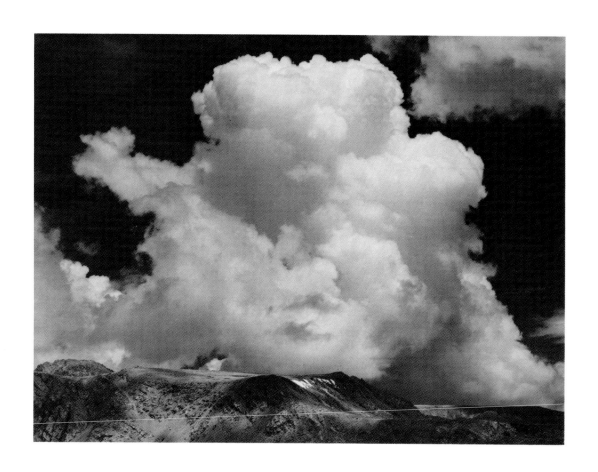

**Architecture, Laurel Hill Cemetery,
San Francisco, California, ca. 1936**

Original exhibition print lent by the Art Institute of Chicago, the
 Alfred Stieglitz Collection
14.7 x 18.1 cm

Adams recalls that various San Francisco architects "vied to show off"*
in their designs for tombs at Laurel Hill. This hodgepodge is made of
Sierra granite, and Adams crowds the picture with the architectural
details photographed head on. This photograph has never been repro-
duced and has not been exhibited since 1936.

Plate 39

Early California [German Language] Gravestone,
Laurel Hill Cemetery, San Francisco, California, ca. 1936

Original exhibition print unidentified

Substitute exhibition print, made in 1981, lent by Ansel Adams
18.7 x 23.1 cm

Adams recalls that he composed this image carefully, making sure to
"true-up the bottom letter-line."* He carefully cropped the image, and
as always, gave scrupulous attention to clean edges.

 In March 1947, Nancy Newhall wrote to Adams that John Marin
had selected this image from those prints left at the Place after Stieglitz's
death. Marin's daughter-in-law, Norma, cannot locate the print, and
no other vintage prints are known.

Plate 40

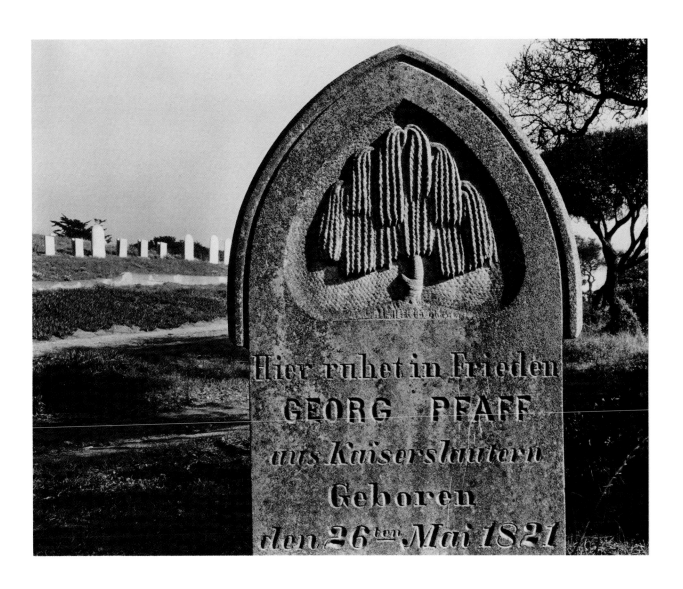

Early California Gravestone, **Laurel Hill Cemetery,**
San Francisco, California, ca. 1936

Original exhibition print unidentified

Substitute exhibition print, made in 1981, lent by Ansel Adams
19.4 x 21.7 cm

Because the title is general and the image is not included in any of the
installation photographs, the exact identification of the negative was
not possible. Adams has made a substitute print from a negative that is
typical of the period.

Plate 41

Anchors, San Francisco, California, 1931

Original exhibition print lent by the Princeton University Art Museum,
 Gift of David Hunter McAlpin
16.0 x 22.3 cm

Adams made this photograph on a foggy day at Fisherman's Wharf.
He used a strong red filter "which elevated the corroded values of the
second anchor"* to differentiate them and describe their texture. This
image was reproduced on the cover of a literary periodical published
in Oceano, California, entitled _Dune Forum_ for their May 15, 1934,
issue. Adams also included this typical f/64 image in most of his early
1930s exhibits, but it has been seldom exhibited or reproduced since.

David McAlpin selected this print from among those left at the
Place after Stieglitz's death. He wrote to Adams, "I do not have any-
thing like it."[†]

[†]Letter from David McAlpin to Ansel Adams, March 19, 1947, AAA/CCP.

Plate 42

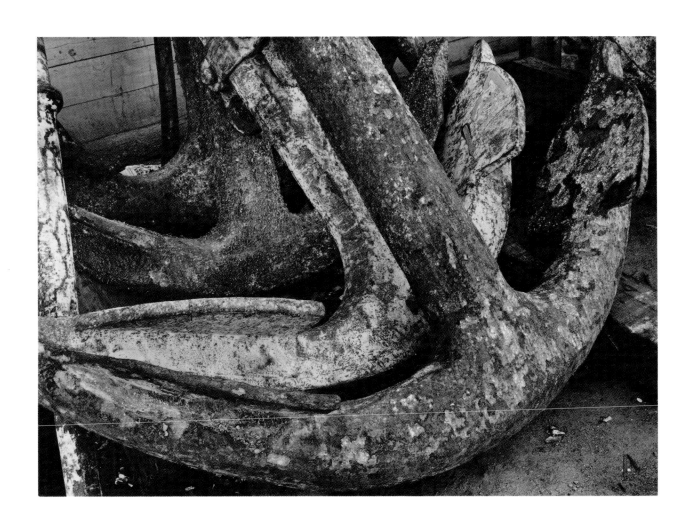

Autumn, Yosemite Valley, California, ca. 1933

Original exhibition print lent by the Art Institute of Chicago, the
 Alfred Stieglitz Collection
18.9 x 23.9 cm

Adams has photographed in Yosemite Valley over many fall seasons,
and there are several images from the 1930s that he titles *Autumn, Yosem-
ite Valley.* This particular image has not been reproduced or exhibited
since the mid-1930s, but Alfred Stieglitz liked it well enough to choose
it for his own personal collection. Adams remembers that the scene
was suffused with very quiet, hazy sunlight and that he used a filter
to exaggerate the variety of fall coloring.* The scene is near the south
wall of Yosemite Valley, probably near Cathedral Rocks.

Plate 43

Steel and Stone (Shipwreck Detail),
San Francisco, California, 1931

Original exhibition print unidentified

Substitute exhibition print, made in 1981, lent by Ansel Adams
19.2 x 24.6 cm

The coast at Land's End at the entrance to San Francisco Bay is rugged, and many ships have foundered and sunk there. Adams was familiar with the area because his family home was on the dunes nearby, and he used to scramble around the cliffs and beach as a child. In the early 1930s he made a series of photographs of details of the wrecks, of which this is one example.

The original exhibition print is unidentified, and there are no known vintage prints of shipwreck details. It was impossible to identify the correct negative given the general title and the difficulty in reading the image in the installation photographs. Adams therefore selected a characteristic image from the series and printed it for inclusion in the re-creation of the show.

Plate 44

Sutro Gardens (Lion at Entrance), San Francisco, California, ca. 1932

Original exhibition print lent by the Museum of Modern Art, New York, Gift of Ansel Adams
15.0 x 20.1 cm

This lion and its mate stand at the entrance to Sutro Gardens in San Francisco where Adams often photographed in the 1930s (Plate 34 was also made there). The structure visible in the background is the Victorian entrance gate that led to the walks. The juxtaposition of the lion and the sign, typical of Group f/64's humor, is unusual in Adams's later work.

Plate 45

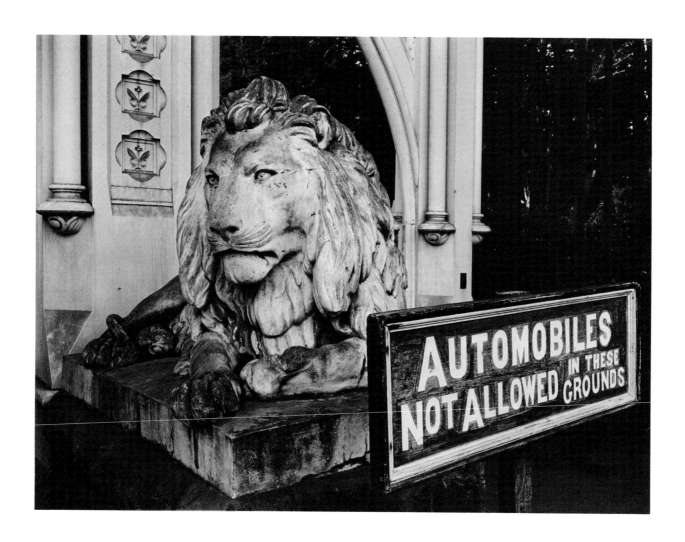

DESIGNED BY NANCY SOLOMON
COMPOSED IN BEMBO BY TIGER TYPOGRAPHICS
PRINTED BY ISBELL PRINTING
BOUND BY ROSWELL BOOKBINDING